DOUBLE EXPOSURE

MOVEMENTS, MOTIONS, MOMENTS

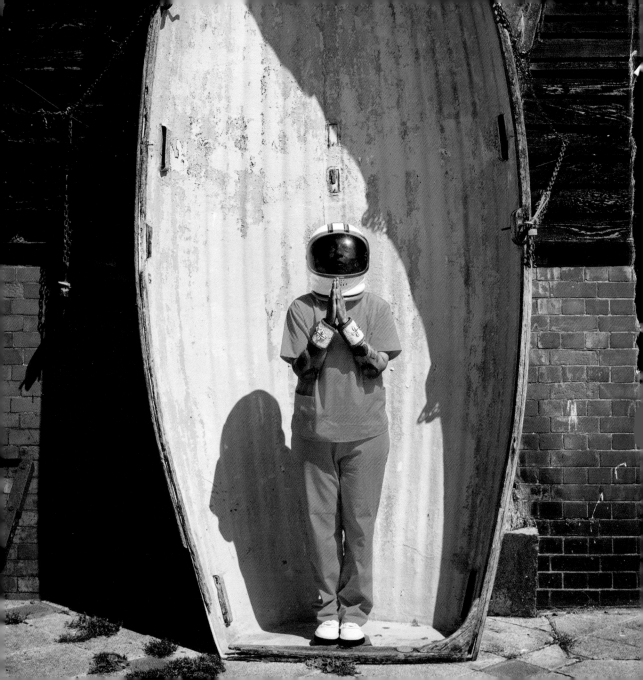

DOUBLE EXPOSURE

MOVEMENTS, MOTIONS, MOMENTS

Photographs of Religion and Spirituality from the
National Museum of African American History and Culture

NATIONAL MUSEUM
of AFRICAN AMERICAN
HISTORY & CULTURE

Earl W. and Amanda Stafford Center for African American Media Arts
Center for the Study of African American Religious Life

GILES

National Museum of African American History and Culture
Smithsonian Institution, Washington, D.C., in association with D Giles Limited
This project is supported by the Lilly Endowment, Inc.

For the National Museum of African American History and Culture
Series Editors: Laura Coyle and Michèle Gates Moresi

Project Coordinator: Douglas Remley

Publication Committee: Bacarri Byrd, Laura Coyle, Michèle Gates Moresi, Loren E. Miller, Teddy Reeves, Douglas Remley, and Eric Lewis Williams

For D Giles Limited
Copyedited and proofread by Jodi Simpson
Designed by Alfonso Iacurci
Produced by GILES, an imprint of D Giles Limited
Printed and bound in Europe

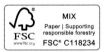

MIX
Paper | Supporting responsible forestry
FSC
www.fsc.org
FSC® C118234

Copyright © 2023 Smithsonian Institution, National Museum of African American History and Culture

First published in 2023 by GILES
An imprint of D Giles Limited
66 High Street
Lewes
BN7 1XG
gilesltd.com

ISBN: 978-1-913875-19-0

All measurements are in inches and centimeters; height precedes width.

Photograph titles: Where a photographer has designated a title for his/her photograph, this title is shown in italics. All other titles are descriptive, and are not italicized.

Front cover: *Ancestral Memorial, Coney Island*, 1995 (detail), Chester Higgins
Back cover: *Queen Quet Marquetta L. Goodwine Outside of a Praise House, St. Helena Island, SC*, 2014 (detail), Pete Marovich
Frontispiece: *Divinity*, 2020 (detail), Lola Flash
Page 6: *Young Female Choir*, 1940 (detail), Alexander Alland

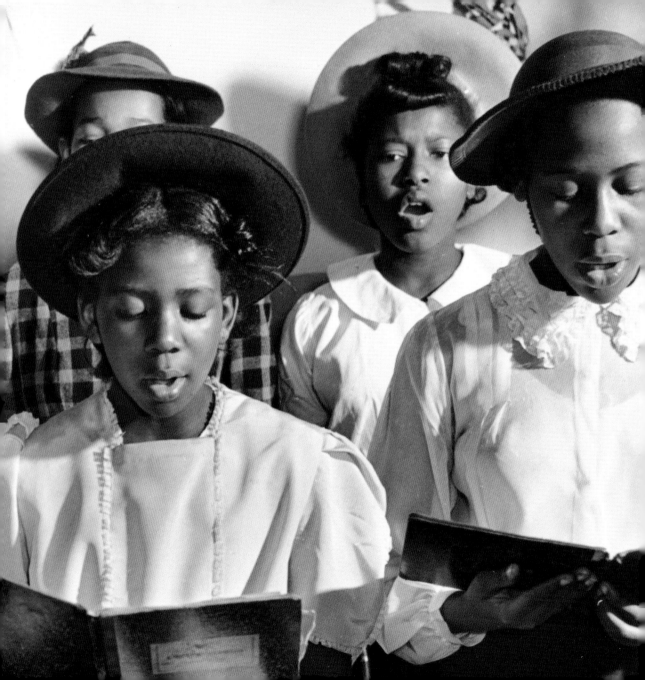

Foreword

The National Museum of African American History and Culture was built on faith. I mean this not only in a religious sense—it took a core of persistence, resilience, and trust to get the Museum built, beginning in 1915 with Black veterans of the Civil War who petitioned for a monument on the National Mall dedicated to their service and sacrifice. But the Museum, finally realized and opened in 2016, also has religious faith and spirituality as its bedrock, coursing through its floors and exhibits, central to the history and culture that African Americans have made. In its soaring feeling and exhibitions, the Museum itself can feel like a sacred space much like others that African Americans created, kept, and found their freedom in, singing of victory in the face of those who would deny their humanity.

In this eighth volume of the *Double Exposure* series, we turn our attention to the dynamic expression of religion and spirituality by African Americans from the late 19th century to 2020. Although no single publication could fully represent such richness, this publication is notable for its inclusion of expected and unexpected religious and spiritual practices. There's imagery from the funeral of Harriet Tubman, a spiritual warrior whose hymnal is a highlight of the Museum's collection; a choir of young Jewish women, their hats just so; an array of ceremonies, including Muslim moments of worship, Rosh Hashanah commemorations, and Baptist praise hands and church fans; the assassinated Malcolm X (El-Hajj Malik Shabazz) in his casket; an image of pioneering Rev. Dr. Pauli Murray being ordained at the National Cathedral; and multiple movements of protest and peace, the pulpit and the street corner preached from, whether that's Rev. Dr. Martin Luther King Jr. or more contemporary protestors as part of the long Freedom Struggle.

This volume features two compelling essays that focus on the Museum's photographs to examine the ways that African Americans practice and engage with religion and spirituality and affirm Black agency and belief. In "Through a Glass Darkly," Eric Lewis Williams introduces the three concepts—movements, motions, and moments—that guided the selection and arrangement of the photographs. Judith Weisenfeld follows with "The Presence of Power and the Power of Presence," which explores how photographers capture and portray personal experiences of spiritual power. We are honored to have additional contributions from Melanee C. Harvey, Anthony B. Pinn, and Teddy Reeves.

There are two key initiatives and centers to which this volume owes much. The Center

for the Study of African American Religious Life (CSAARL) was established in 2016 thanks to a generous grant from the Lilly Endowment, Inc. CSAARL is the first center of its kind for any museum in the US, dedicated to researching and preserving the role of religion and spirituality in the lives of African American people through groundbreaking scholarship, public programs, and collecting religious artifacts. The Museum's photography collection also supports our innovative Earl W. and Amanda Stafford Center for African American Media Arts (CAAMA) as a physical and visual resource within NMAAHC and exemplifies the Museum's commitment to preserving African American history and culture. A number of these photographs were first brought to the public through exhibitions in the CAAMA space.

This series continues thanks to the many people who have collaborated on this important volume. Special acknowledgement goes to the Publication Team: Bacarri Byrd, Curatorial Assistant; Laura Coyle, Head of Cataloging and Digitization; Michèle Gates Moresi, Supervisory Museum Curator of Collections, who serves with Laura as co-editor of this series; Loren E. Miller, Museum Specialist; Teddy Reeves, Curator of Religion; Douglas Remley, Rights and Reproductions Specialist and Project Coordinator for the series; and Eric Lewis Williams, Curator of Religion. A word of thanks also goes to Donna Braxton, Management Support Specialist; Aaron Bryant, Curator of Photography; Kim Moir, Museum Specialist;

and Tulani Salahu-Din, Museum Specialist. Ongoing support and encouragement from the Museum's Deputy Director, Kinshasha Holman Conwill, and from Associate Director for Curatorial Affairs Dwandalyn R. Reece, has been invaluable to the continuation of the series.

We are also very fortunate to have the pleasure of co-publishing with D Giles Limited, based in the UK. We would like particularly to thank Dan Giles, Managing Director; Alfonso Iacurci, Designer; Allison McCormick, Managing Editor; Louise Ramsay, Production Director; Jodi Simpson, Copyeditor and Proofreader; and Liz Japes, Sales and Marketing Manager.

Finally, I would like to thank the Museum's Office of Collections Management for preparing the photographs for imaging and our Digitization Team for researching, cataloging, and digitizing the images included in this volume.

I am proud to continue this landmark series with a volume focused on African American religion. We at the Museum remain committed to documenting the diversity of African American religious and spiritual practices, and I know you will be moved by these images highlighting the strength of Black belief.

Kevin Young
Andrew W. Mellon Director
National Museum of African American History and Culture

Through a Glass Darkly: Movements, Motions, and Moments in African American Religious Photography

Eric Lewis Williams

National Museum of African American History and Culture

"For now we see through a glass, darkly; but then face to face: now I know in part; but then shall I know even as also I am known." 1 Corinthians 13:12[1]

The story of African American religion as captured through the photographer's lens is a story of divergent movements, motions, and moments. In one sense it is a reductionist endeavor, in that the photographer faces the impossibility of capturing an entire religious universe with a lens mere centimeters in diameter. Yet, in another sense, the photographer's lens provides the viewer with a window into the very heart and soul of the Black religious experience.

In creating portals into this experience, the discerning photographer captures and immortalizes frames that are at once holy and profane; images that capture moments of intense protest and praise, in seasons of suffering and hope. The photographs represented in this volume depict religion as both a universal phenomenon and an expression of the human spirit, showing us that which is essential to a Black aesthetic and religious ethos.

Not only are photographers chroniclers of time and human experience, but the images they capture present to the world mirrors for self-examination, reflection, and discovery. In each image that is framed, through hues, tones, and shadows stilled by time and resolve, the beholder is made witness to a beauty that both resonates with and transcends our personal experiences, inspiring awe, reverence, wonder, and contemplation.

One vivid example of this beauty can be seen in the artistic production of the Pulitzer Prize-winning photojournalist John H. White. White, himself the son of an African Methodist Episcopal minister and child of the Black church tradition, captures with great reverence, precision, and devotion a highly intimate moment in the spiritual life of the

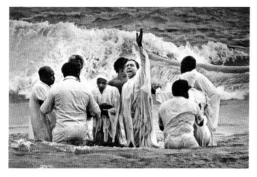

Untitled, September 1981
A baptism in Lake Michigan
John H. White

Church of God in Harvey, Illinois, during a baptismal service on Lake Michigan. In the early twentieth century, Lake Michigan's beaches, particularly those near major urban areas, remained racially segregated. In the wake of the Great Migration, many African Americans from the South relocated to cities along the coast of the lake, including Chicago, Milwaukee, Gary, and Muskegon. Having abandoned the waterways and creeks of the rural South, these migrants frequently utilized the shores of Lake Michigan to conduct public baptisms. It is this reality that White's visual artistry so poignantly engages.

White, through the dilation of his lens alone, fully immerses the viewer in the sacramental waters of baptism. In traditions that nurture and sustain this practice, water and Spirit, both instrumentalities of new birth, are proclaimed as material witnesses to the devotees' confession of faith. For White, this new birth is captured by images of the looming waves and expansive lake that threaten to overwhelm the devotees, in anticipation of the transfiguring moment of new life that

has already begun. The photographer, also wading in the water, serves as a proxy, providing the viewer a way to witness the holy moment laid bare. Water and waves buoy, lifting the men and women dressed in white baptismal garments, to reveal the contours of their redeemed flesh and triumphant souls. Baptism from the Christian perspective signifies the death, burial, and resurrected life of Christ, a sacramental act. This rite takes on additional layers of meaning as it relates to the involuntary transatlantic passage and the possibilities for new birth and new world identity.

Newly initiated men and women that undergo this rite are accompanied through the process by those who have "already been to the water," as referenced in the Negro Spiritual.[2] As if summoning power from a transcendent realm, the baptizer with raised hand declares the entry of the sacred into time, where the baptized are joined in beloved community with ancestral spirits, confirming the transformative capacity of the ritual of baptism. Despite the stillness demanded by the medium depicted in black and white, the photographer captures the dynamism of the moment while conveying the sense of continual movement of the baptismal waters.

As the title of this volume indicates, the images within are organized into three

Sisters of the Holy Family disembarking on a mission to Belize, 1898 (detail)
Unidentified photographer

others—are often influenced by a range of African- and Caribbean-derived religious expressions. With respect to the places of worship and ritual contexts represented, these images portray adherents of these movements gathered in churches, homes, mosques, synagogues, temples, nature, and other designated sites set aside for experiences of human flourishing, transcendence, and/or religious practices.

sections: *Movements*, *Motions*, and *Moments*. Although many of the photographs, like White's, could be at home in more than one section, they have been carefully arranged by theme to provide a panoramic view of religious diversity within Black communities in the United States—and in the NMAAHC collection. The images become syncopated refractions of light and darkness through which the photographer exercises their craft, cultivating a body of work worthy of the viewer's attention.

 In this volume, *Movements* refers to the vast complex of Black religious organizations and traditions that have historically reflected (and continue to reflect) the worldviews, belief structures, ritual practices, traditions, symbols, arts, and cultures of people of African descent in the United States. The movements represented here—Christian, Muslim, Buddhist, Jewish, Humanist, Wiccan, Rastafarian, and

 Motions explores the ways in which Black bodies engage in the ritual practices of religion. These embodied forms of ritual participation may occur in sacred or mundane spaces and often involve dancing, kneeling, or lying prostrate. It has long been observed that embodiment in Black worship is a retention from the African past. It has even been suggested that African-derived religion is more "danced out" than "thought out," and that motion is a persistent feature of Black religious expression.[3]

 In addition to being perceived in relation to its African past, motion, as a mode of bodily communication, is expressed through ritual participation. Embodiment is also a way of affirming one's sense of agency, reclaiming one's body while defying the oppressive systems and structures that seek to suppress Black life and deny humanity. Motion within this context is also a way in which adherents

connect with the holy, mythic, or spiritual realm. It elevates the body as an instrument in service of the gods and the holy, and defers to the ancestors that light the path forward.

Moments captures the cycles, seasons, and celebrations within Black religious communities that are marked by ritual acts and viewed by the adherents of these traditions as sacred or other than ordinary. These moments are often perceived as being invested with sacred power or theological possibility, or as possessing special religious meaning. The sacredness or momentous nature of these occasions comes into full view during the rites of baptism, weddings, births, naming ceremonies, confirmations, burials, bar and bat mitzvahs, altar calls, and other holy days and moments of ritualistic significance. These holy days include Advent, the Feast of Yemanja, the Day of the Dead, Yom Kippur, Kwanzaa, Watch Night, Ramadan, and the New World Passover. Despite the variations of these practices, what is significant is that these are all defining moments in the life of an individual and community, bearing on their identity, hopes, and realities. These moments stand in contradistinction to or apart from other moments, giving shape to some essential quality of life. Such holy moments captured by photographs leave markers in time for the

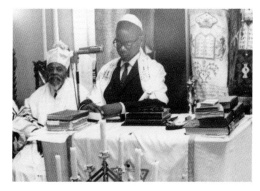

David Doré's bar mitzvah ceremony overseen by his grandfather, Rabbi Wentworth A. Matthew, at the Commandment Keepers Ethiopian Hebrew Congregation in Harlem, New York, ca. 1968 (detail)
Lloyd W. Yearwood

adherents, a way of being remembered. At the same time, these moments elevate and form a bridge for the adherents to join a community of belief that precedes them.

This publication seeks to visually expand our conception of a Black religious experience whose participants understand their religious journeys as those who "see through a glass, darkly." This vision determines the contours and shape of their future and their understandings of the beloved community. It is our hope that after viewing these images, Black religious expressions long obscured will be more accessible, and no longer rendered invisible, nameless, or inaudible.

1. To see "through a glass"—a mirror—"darkly" refers to having an obscured or blurred vision of reality. W. E. B. Du Bois and Howard Thurman allude to St. Paul's writings to suggest reality is not always clear, contrasting with a vision marked by clarity and divine intention.
2. Arthur C. Jones, *Wade in the Water: The Wisdom of the Spirituals* (Maryknoll, NY: Orbis Books, 1993).
3. Henry H. Mitchell, *Black Belief: Folk Beliefs of Blacks in America and West Africa* (New York: Harper & Row, 1975).

The Presence of Power and the Power of Presence

Judith Weisenfeld
Princeton University

The energy in Kenneth Royster's photograph *The Baptism of Ms. Robinson* is startling. The drops of water flying from her outstretched hands seem to come toward the viewer as she stands upright in the moment after having been submerged in a body of water by the two men standing on either side of her. Royster captures Robinson with her eyes closed and her mouth open. She draws a breath and perhaps makes a sound. The image conveys the power of her experience of divine presence, her body expressing exhilaration in a profound moment of transformation.

A different sort of energy is apparent in Jeanne Moutoussamy-Ashe's *A Moment of Silent Prayer* (see page 14). Where the spiritual energy of Robinson's baptism propels outward from Royster's photograph toward the viewer, the face of the unidentified elderly man in Moutoussamy-Ashe's photograph is obscured and turned away from the camera, his chin resting on his arm draped across the back of a chair or pew. We see the side of his head with most of his face in shadow, but his ear, sharp

in the light, stands out as if he were listening for God. Royster's image of Robinson captures a moment of change as she is baptized and made new. Moutoussamy-Ashe captures what seems to be the power of enduring faith as the man communes silently with God, a presence familiar and comforting.

The contrasting feelings conveyed in these two photographs highlight the artistry photographers have demonstrated in trying to capture and portray the ineffable qualities of

The Baptism of Ms. Robinson, 1995
From the series **Praise**
Kenneth Royster

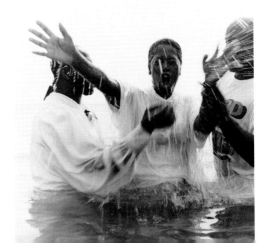

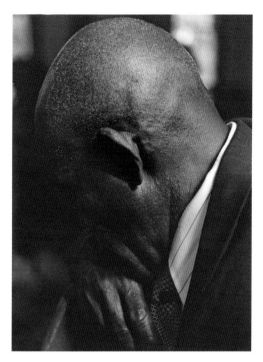

A Moment of Silent Prayer, 1979;
printed 2007
From the series **Daufuskie Island**
Jeanne Moutoussamy-Ashe

have explored the presence of spiritual power in many ways. Some mobilized photographic technology to represent spiritual dimensions. In the funeral portraits from the 1920s and 1930s included in his *Harlem Book of the Dead*, James Van Der Zee used photomontage to superimpose images of Jesus and angels, biblical text and poetry above open caskets, bridging life and death to bring the living and the dead together once more.[1] These photographs told stories of past, present, and future through visual layers that appeared in different degrees of saturation within the same frame. In doing so, Van Der Zee called on African Atlantic religious sensibilities and practices that attuned the living to the dead.

More commonly, photographers have focused on portraying the religious emotion of Black worshippers, as exemplified in Royster's depiction of the exuberance of Robinson's baptismal experience, Moutoussamy-Ashe's image of the elderly man's quiet communing with God, the Muslim man bowed in prayer in Chester Higgins's photograph (see page 74), and Jason Miccolo Johnson's images of Black church services (see pages 23 and 32). Religious emotion, as indexed in the history of American photography and in other visual representations, has been a fraught concept for African Americans.

personal experiences of divine power, whether in Black Christian contexts, as in the case with these two images, or in religious modes and communities that represent the broader diversity of African American religious life and cultures. From the time of photography's invention, those who produced images and those who gazed upon them wondered whether the technology could reveal powers, persons, and dimensions beyond our material reality and open new means of access to the spiritual.

African American photographers capturing aspects of Black religious life

Throughout American history, white religious, political, educational, and medical authorities have claimed religious emotion as an innate racial characteristic of people of African descent. Such authorities have sometimes deployed the notion of inherent religious emotionalism to characterize Black religion as authentic yet simplistic, but they have also denigrated it as excessive to a degree that required protecting the white social and political sphere from what they argued was Black religious fanaticism.[2] African American religious and political leaders engaged the topic of religious emotion, and some argued that tempering religious emotion, which they set in contrast to rational religion, was necessary for social, political, and economic progress. Photographic representations of African Americans' religious emotion sometimes contributed to demeaning interpretations of Black life and culture. At the same time, photographers have also given us a rich and moving catalog of images of emotional expression that convey the power of spiritual presence in the lives of individuals and communities.

Many photographic chroniclers of African American religious life have explored the presence of Black churches and their power as community institutions. In the image by an unidentified photographer of members of Vernon African Methodist Episcopal Church in Tulsa, Oklahoma (see page 37), we see the fruits of the community's labor to establish a physical presence, represented in the church building behind them, and project middle-class respectability. The photograph captures members as the church was in the process of constructing a new brick building on Tulsa's Greenwood Avenue, the nation's most prosperous African American community. Just two years later, a white mob would destroy Greenwood, killing hundreds of Black Tulsans. The church's new brick building sheltered those seeking refuge from the violence, fires, and bombing, and Vernon AME's basement is the only structure owned by Black residents to survive the massacre. The image pictures a proud community, whose success white Tulsans found threatening. Vernon's members recovered the bricks from their destroyed church and rebuilt to maintain an enduring presence in the city.

Black Protestant clergy have been important figures in documenting African American religious life in photographs and on film, portraying the power of religious community amidst the broader landscape of life and culture. Memphis, Tennessee, Baptist minister Rev. L. O. Taylor left a rich portrait of everyday life, including church life in the city and National Baptist Convention

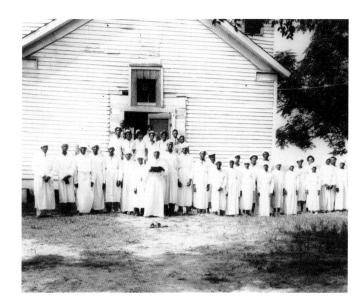

Group portrait in front of a church, in or near Greenville, Mississippi, mid-20th century
Rev. Henry Clay Anderson

activities to which he traveled.[3] Rev. Henry Clay Anderson of Greenville, Mississippi, was an avid photographer with a professional studio that attracted Black residents from all walks of life seeking portraits of themselves and their professional accomplishments, their children and families, and their church congregations, and to document major events, such as sporting events, birthdays, graduations, weddings, funerals, and baptisms. His portrait of an unidentified group of several dozen men, women, and children standing outside a wooden church building, dressed in white, signals the growing presence of believers as they stand ready to be incorporated into the Christian community through the ritual of baptism. The image is almost timeless as the few men in suits and ties in the back give the only hint of styles of the time amidst the rows of white robes.

We see a captivating representation of the significant presence of women and their labor that gives power to Black church life in John H. White's untitled image. Shot from above, the photograph documents "the labor of faith" these women give to their church and community.[4] Although not always in positions of public or ordained leadership, African American women contribute many kinds of vital labor that supports Black religious life and through which they convey religious authority. In White's photograph, we see such labor expressed materially and spiritually in the women's careful preparation for the Lord's Supper. The image contains aspects that are both quiet, as one

Untitled, late
20th century
John H. White

woman stands in the pulpit facing the altar and observes the activities, and active, with most of the rest of the women in motion, carrying the communion tray, laying table linens, and inspecting the progress of others.

The photographs represented in this volume not only document the presence and power of religion in African American history, life, and culture, they also have the power to articulate boundaries of the category of religion itself and create a sense of belonging or exclusion. Protestant churches, commonly referred to collectively as "the Black Church," represent the majority institutions of African American religious life and dominate photographic representation. The few images of Black Catholic priests (see pages 35 and 58), sisters (see pages 31 and 48), and congregants in this book leaves a relative void in representation of Black Catholic life. The emphasis in the work of many Black studio photographers on respectability produces one sort of image and captures the experiences and expressions of some, while leaving others whose religious lives were not in mainstream institutions largely outside the frame.

Some aspects of Black religious community in America not connected to Protestant churches *did* capture the attention of photographers. Images of Noble Drew Ali of the Moorish Science Temple (see page 24), Elijah Muhammad, Malcolm X, and members of the Nation of Islam (see pages 38 and 39), members of congregations of Black Hebrews

(see pages 67 and 69) and of Father Divine (see page 50) help to expand the scope of visual representation of African American religion in additional ways. Representation was deeply important to leaders and members of these groups, and they deployed visual means to distinguish themselves theologically and socially from the Black Protestant mainstream. Often such images are tied to political engagement and protest grounded in religious commitment, much like the many images from the Civil Rights Movement featured in the Museum's collection. But images like Alexander Alland's photograph of children in the Hebrew School of Harlem's Commandment Keepers' Ethiopian Hebrew Congregation, turn our attention to the power of transmitting faith and practice across generations and to the complexity and variety of Black religious expression.

Many dimensions of religious experience and expression lie beyond what can be captured and represented by the camera, but photographers have left us with a rich and extensive archive. The visual record of African American religious life and cultures collected in this book provides a captivating portrait of how African Americans have engaged the power of spiritual presence and of the significant presence of Black religious individuals, institutions, and communities in American life.

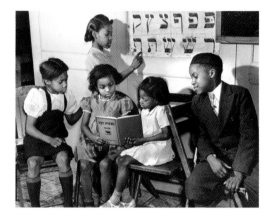

Children Studying, 1940
From the series **The Commandment Keepers: African American Jewish Congregation in Harlem**
Alexander Alland

1. Diana Emery Hulick, "James Van Der Zee's *Harlem Book of the Dead*: A Study in Cultural Relationships," *History of Photography* 17, no. 3 (Autumn 1993): 277–283.
2. Curtis J. Evans, *The Burden of Black Religion* (New York: Oxford University Press, 2008).
3. Lynne Sachs, dir., *Sermons and Sacred Pictures: The Life and Work of Reverend L. O. Taylor* (Brooklyn, NY: Icarus Films, 1989).
4. On the idea of "the labor of faith," see Judith Casselberry, *The Labor of Faith: Gender and Power in Black Apostolic Protestantism* (Durham, NC: Duke University Press, 2017).

MOVEMENTS

Anthony B. Pinn
Rice University

United States anti-Black racism functions in part by warping the appearance of Black people and relegating them into their "proper," inferior place in society. White supremacists used photography as a weapon to buttress their anti-Black assumptions. They used images to claim that white privilege resulted from the natural order, rather than from its actual source, white political power. Yet, for as long as anti-Blackness has existed, Black people have fought it, creating and adapting tools to meet a full range of needs. They made the camera serve a different purpose: countering stereotypes and other misrepresentations of Black life and culture. The record of resistance is not just written; it is also captured on film, in photographs that portray dignified Black people in a variety of spaces, images that demand respect, capturing the beauty and wholeness of their humanity.

Many of the images in this section involve religious movements. While a growing number of Black people claim no religious affiliation, many more believe that religion in Black communities is affirmative, whether it be Christianity, Islam, Spiritualism, Buddhism, or based in African traditions. Images of Black people practicing the faith of their choosing offer new and positive portrayals of their spiritual life.

Photographs of Black people wearing distinctive or "good" clothing, moving their bodies in ritual, or sharing teachings that express the worth of Black life counter racist claims and images. Depictions of African American Baptists, Methodists, Episcopalians, and others preaching and singing highlight their value in society and within the cosmic ordering of the world. Think, for example, of the African Methodist Episcopal Church: the name itself, *African*, proudly asserts that this church is for and run by Black people and a center of vital Black life, challenging stereotypes about Black agency, ability, and community. Black people, they and others proclaim, are made in the image of God–or, as Bishop Henry McNeal Turner argued, "God is a Negro!"

All these images speak to the deep significance of Black people within their religions. Father Divine (see page 50) proclaimed his own divinity, while Sweet Daddy Grace, founder of the United House of Prayer for All People, channeled a "new" relationship between people and God. The Nation of Islam proclaimed the divine status of its founder, Fard Muhammad, and of the "Black man,"

created by Allah and possessing a special status and supreme knowledge found only within the Nation of Islam's teachings. For some Black people, widely practiced traditions fail to recognize Black life as rooted in powerful African cultures. To gain a greater connection to their heritage and find practices they believe are more consistent with the history of Black people, they embrace African–based traditions such as Voodoo or Lucumi.

Jesse Jackson at Abyssinian Baptist Church, ca. 1988
Lloyd W. Yearwood

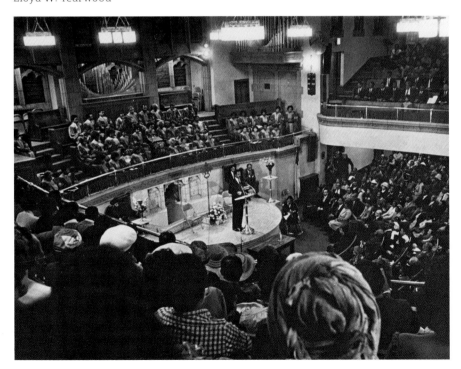

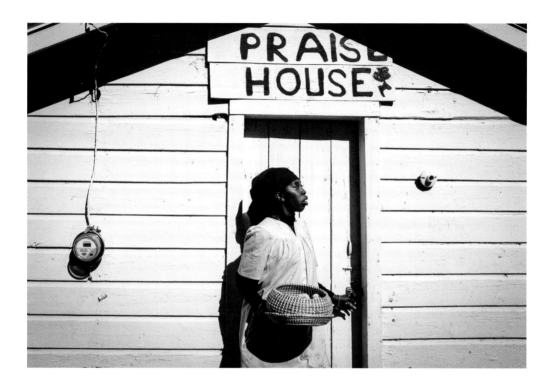

Queen Quet Marquetta L. Goodwine Outside of a Praise House, St. Helena Island, SC, 2014
From the series
Shadows of the Gullah Geechee
Pete Marovich
—

Marquetta L. Goodwine, or Queen Quet, as she is known throughout the Gullah-Geechee Corridor, is widely regarded as chieftess and head of state of the Gullah/Geechee Nation. An artist, social commentator, and cultural preservationist, Queen Quet rose to prominence in 1999 after testifying before the United Nations' 55th Session of the Commission on Human Rights.

She is pictured standing before one of the last three remaining praise houses on St. Helena Island, South Carolina. For the enslaved and their descendants, praise houses were sites of deep humanization and spiritual empowerment. As places of worship away from the gaze of enslavers, praise houses provided sacred spaces to reconstitute broken bodies and personhood through rituals of singing, praying, and shouting, all cultural retentions from their African religious past.

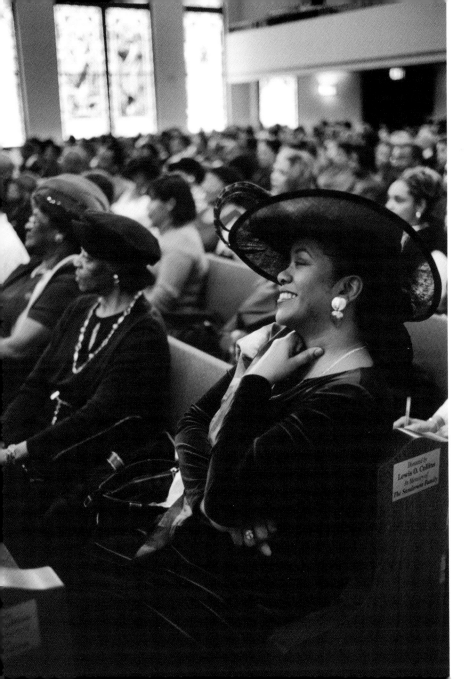

Mrs. Lisha Morris, the First Lady of the Lane Tabernacle CME Church, Enjoys a Laugh during Morning Services, St. Louis, Missouri, 2005; printed 2012
Jason Miccolo Johnson

***Prophet Noble
Drew Ali, Founder
of Moorish
Science Temple of
America***, 1925
R. D. Jones

—

As prophet and founder
of the Moorish Science
Temple of America in 1913,
Noble Drew Ali established
the first mass Islamic
religious community
in the US. In doing so,
Ali instituted a Black
nationalist framework upon
which future traditions of
African American Muslims
would build. Ali believed
that all Black Americans
were of Moorish ancestry
prior to the experiences of
chattel slavery and racial
dehumanization. Ali's
mission, therefore, was
to restore their dignity
through the teachings
of Moorish Science and
recovery of their African
religious heritage and
identity. Ali also believed
that a full restoration of
Black dignity could only
be achieved through
embracing the teachings
of Islam.

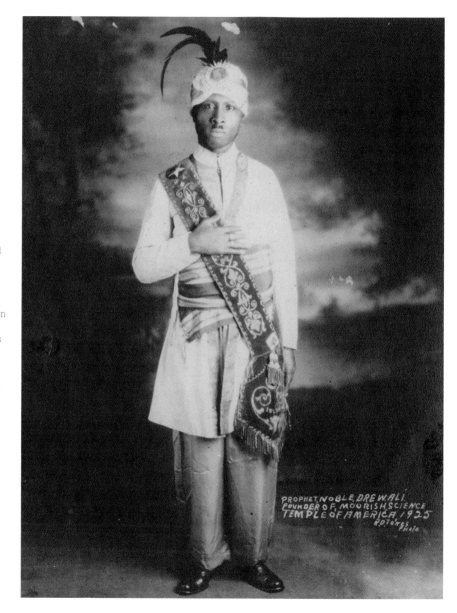

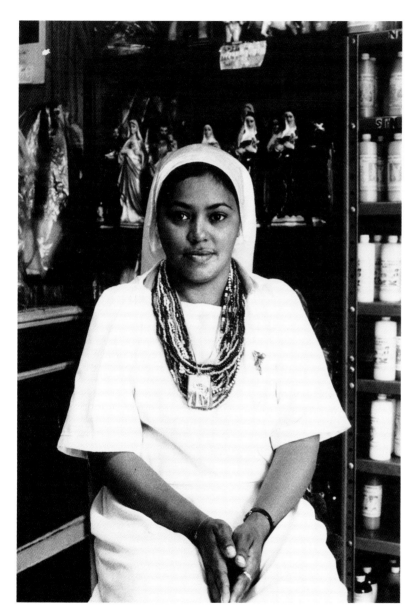

***Marta de Jesús,
Spiritualist***, 1982
From the series
**The Puerto
Rican Diaspora
Documentary Project**
Frank Espada
—

Marta de Jesús grew up
practicing Spiritualism, a
religion based on the belief
that souls of the deceased
can communicate with
the living. Her mother
was a spiritualist medium,
and de Jesús discovered
her own abilities as a
child. She wanted to use
her skills as a medium
to help people and to de-
stigmatize the religion.
So in 1977 de Jesús
founded El Centro San
Lázaro in a closet in her
apartment, creating a
place where people could
go to have misguided
spirits exorcised through
group seances.

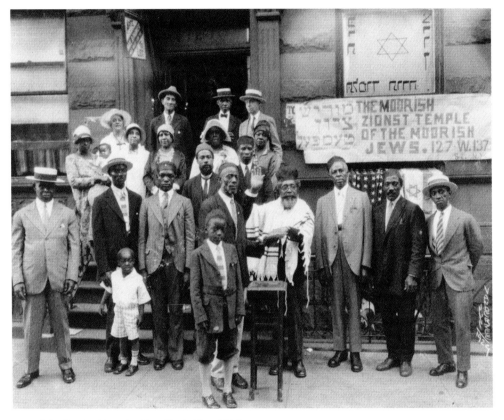

Moorish Zionist Temple, New York City, 1929,
printed 1985
James Van Der Zee

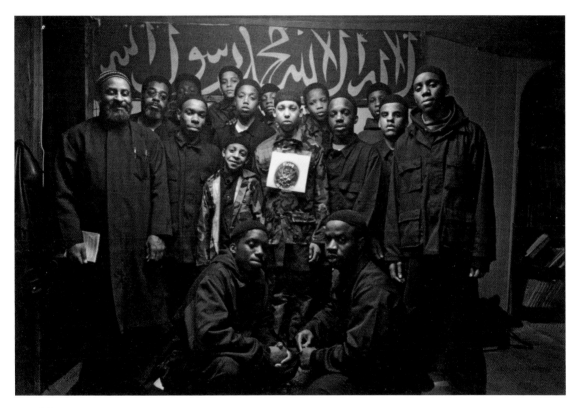

Brooklyn Mosque, 1990
Chester Higgins

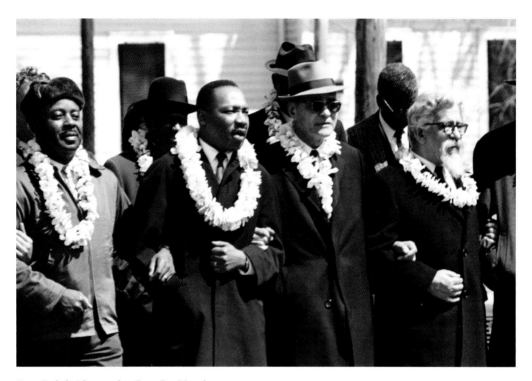

Rev. Ralph Abernathy, Rev. Dr. Martin Luther King Jr., Dr. Ralph Bunche, and Rabbi Abraham Joshua Heschel, Selma to Montgomery March, March 21, 1965
James H. Karales

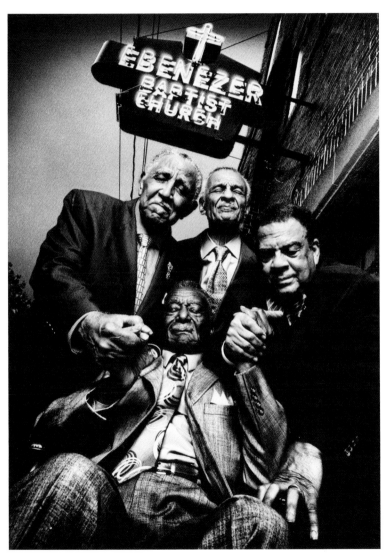

Reverends Joseph Lowery, C. T. Vivian, Andrew Young and Fred Shuttlesworth, 2009; printed 2019
Platon
—

Clockwise from left, Reverends Joseph Lowery, C. T. Vivian, Andrew Young, and Fred Shuttlesworth (seated) are pictured outside Ebenezer Baptist Church, the spiritual home of Rev. Dr. Martin Luther King Jr.

**Chaplain Allen
Allensworth**,
January 15, 1889
Walter L. Elrod
—

Allen Allensworth
emancipated himself from
slavery during the Civil
War and began his life of
freedom by serving in the
Union Army. Allensworth
dedicated his life to
service as a minister,
educator, and soldier. To
extend spiritual support to
Black troops, he petitioned
for an appointment as
a chaplain and in 1886
was assigned to a unit
of Buffalo Soldiers in
the West, where he
served for 20 years. In
retirement he co-founded
the all-Black town of
Allensworth, California.

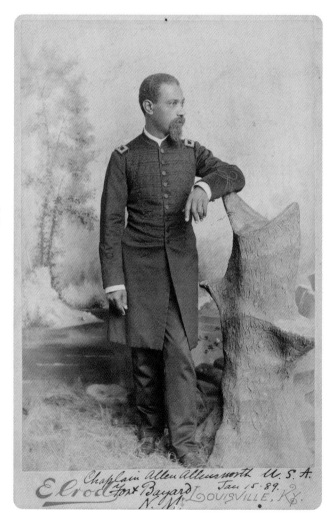

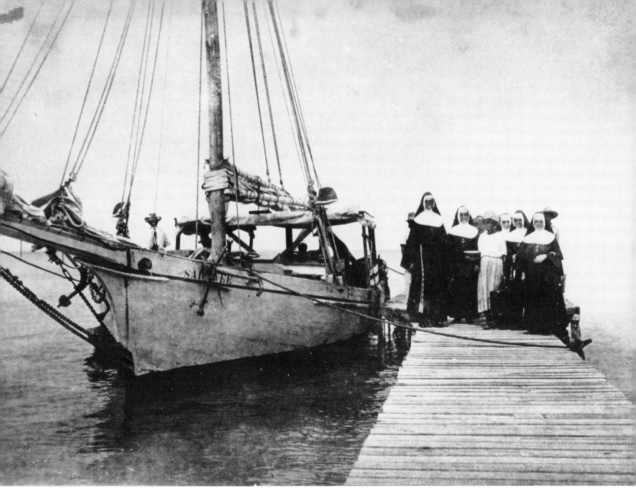

Sisters of the Holy Family disembarking on a mission to Belize, 1898
Unidentified photographer
—

Established in 1842 by the Venerable Henriette Delille, Juliette Gaudin, and Josephine Charles, the Sisters of the Holy Family Catholic order was founded to provide schooling and health care to enslaved people. Through their work, the Sisters of the Holy Family founded several businesses, including the oldest nursing home in the United States, Lafon Nursing Facility in New Orleans. Pictured here, on Palm Sunday 1898, the Sisters of the Holy Family are disembarking from a boat in Stann Creek, Belize, to provide educational support to the children of the Garifuna community. Pictured on the far left is Mother Superior Mary Austin Jones, leader of the Sisters from 1891 until her death in 1909.

With the Aid of Large Projection Screens, Bishop G. E. Patterson, Senior Prelate of the Church of God in Christ and Pastor of Temple of Deliverance, Can More Easily be Seen by Every Member of the Congregation, Memphis, Tennessee, 2005; printed 2012
Jason Miccolo Johnson

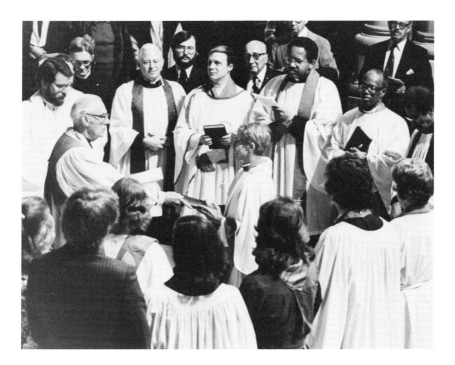

Untitled, January 8, 1977

Rev. Dr. Pauli Murray being ordained at the Washington National Cathedral

Milton Williams

—

Already a distinguished poet, lawyer, teacher, civil rights activist, and feminist, Rev. Dr. Pauli Murray helped lead the movement to ordain women in the Episcopal Church. In her sixties when she was ordained the first female African American Episcopal priest, she wrote that with consecration, "all the strands of [her] life had come together."

She celebrated her first Holy Eucharist at the Episcopal Chapel of the Cross in Chapel Hill, North Carolina, the church where her grandmother, Cornelia Smith Fitzgerald, was baptized. Rev. Dr. Murray used her religious beliefs and ministry to propel her lifelong commitment to social justice.

Rev. Dr. Murray publicly described herself as a woman, but otherwise she did not openly discuss her gender, sexuality, or biological sex. In private, however, she struggled with her identity. In her letters she wrote about her "he/she personality" and the possibility that she was born with sex characteristics that were not typically male or female. During most of her lifetime, people who didn't conform to gender norms were often viciously and publicly attacked. As a powerful advocate for human rights who suffered because of narrow definitions of gender and sex, Rev. Dr. Murray has been warmly embraced by activists for LGBTQ+ rights and respect.

Myokei Caine–Barrett preparing for ordination as bishop of the Nichiren Shu Order of North America, October 25, 2014
Jan Deputy–Louy
—

Despite over one hundred years of existence in the United States, most Japanese Buddhist lineages have remained under Japanese or Japanese American leadership. This trend has changed gradually over the last fifty years. On October 28, 2014, in Boston, Myokei Caine–Barrett was elected bishop of the Nichiren Shu Order of North America, the first woman, first American, and first person of African American and Japanese descent to hold that office. Bishop Myokei is pictured in her traditional garb at the time of her initiation conference.

Based in Houston, Bishop Myokei serves as the resident priest at the Myoken–Ji Temple. Caine–Barrett's ministry places emphasis on social issues, such as racism and mass incarceration. She has played a significant role in reimagining women's roles within a religious tradition dominated by men and has been at the forefront of bridging the gap between social and religious activism.

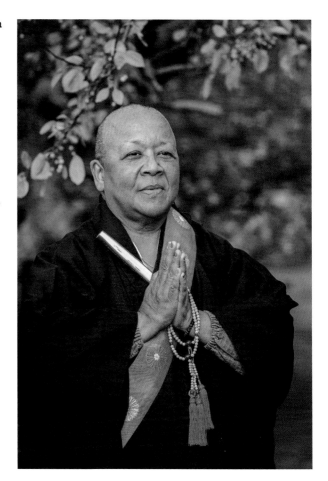

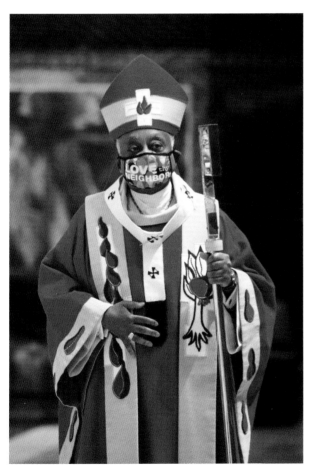

Then–Archbishop (now Cardinal) Wilton D. Gregory during the 2020 Red Mass, October 5, 2020 (detail)
Mihoko Owada
—

A few weeks after the "Red Mass" pictured here at the Cathedral of St. Matthew the Apostle in Washington, D.C., Pope Francis elevated the archbishop of Washington, Wilton Daniel Gregory, to cardinal, the first African American to hold that position. The Red Mass gets its name from the red vestments worn for the Mass of the Holy Spirit, offered annually to justices, judges, diplomats, attorneys, and senior government officials in Washington on the first Sunday of October, the day before the start of the fall Supreme Court term. In addition to his traditional robes and miter, Archbishop Gregory wears a mask to protect himself and others from the global COVID-19 pandemic. The mask's message alludes to a Judeo-Christian tenet: love others as you love yourself.

For all Catholics, but particularly for African American Catholics, Gregory's rise to Cardinal was a long time coming. For centuries, African Americans have practiced Catholicism, but until this historic appointment, African Americans were not represented in the highest echelons of the Holy Roman Church. Cardinals are personally selected by and second only to the pope. They wield considerable powers, which include electing a new pope when the one holding that office steps down or dies.

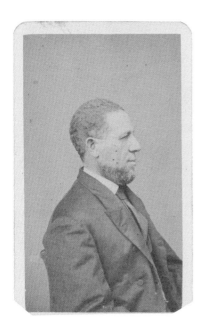

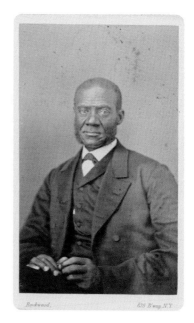

U.S. Senator Hiram Revels, early 1870s
Unidentified photographer

—

Recognized as the first African American member of the U.S. Senate, Rev. Hiram Rhodes Revels was also an ordained minister in the African Methodist Episcopal Church. His skills as an orator, which were honed through his itinerant preaching and his role as a clergyman, propelled him to one of Mississippi's two Senate seats in 1870. As a senator, he spoke eloquently against racial segregation, and championed education and civil rights for Black Americans.

Rev. Henry Highland Garnet, 1860s
George G. Rockwood

—

As a child, Rev. Henry Highland Garnet escaped with his parents from slavery and settled in New York. Nurtured in a community of abolitionists and the Presbyterian Church, he pursued a career in teaching and ministry. Garnet attained national prominence with his bold address to the National Negro Convention in 1843, when he called for enslaved people to rebel and free themselves. In 1865, he gave the first sermon by a Black clergyman before the House of Representatives.

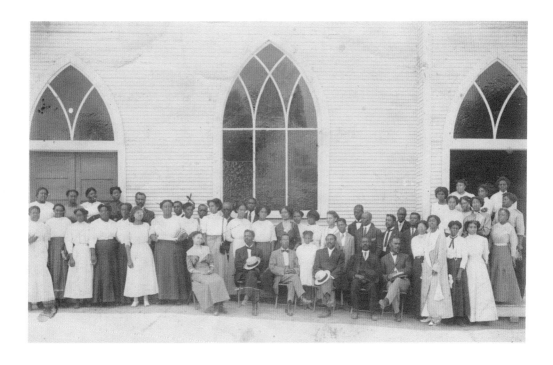

Men and women in front of Vernon AME Church, Tulsa, **Oklahoma**, ca. 1919
Unidentified photographer
—

Vernon African Methodist Episcopal Church was founded in the Greenwood neighborhood of Tulsa, Oklahoma, in 1905. In 1914, a new church with a large brick basement was constructed on North Greenwood Avenue. Once completed, Vernon AME became one of the largest Black churches in Tulsa. From May 21 to June 1, 1921, the thriving African American community of Greenwood suffered the deadliest racial massacre in U.S. history. Although much of the Greenwood neighborhood was destroyed—including most of Vernon's exterior—the church basement survived. After the massacre, the church and its basement served as a community refuge, immediately resuming Sunday services, and even hosting Booker T. Washington High School's graduation ceremony.

Elijah Muhammad,
ca. 1955
Lloyd W. Yearwood
—

From 1934 to 1975, Elijah
Muhammad was the leader
of the Nation of Islam (NOI),
a religious organization
promoting social and
economic self-help and
institution-building among
African Americans. Born
in 1897 in Sandersville,
Georgia, Muhammad
migrated to Detroit,
Michigan, in 1923. Fleeing
racial violence and seeking
radical social reform,
he embraced the Black
nationalist teachings of
Fard Muhammad, founder
of the NOI. Following Fard's
furtive disappearance in
1934, Elijah Muhammad
assumed leadership, and
despite FBI surveillance,
infiltration, and four
years of imprisonment
for refusing the
World War II draft, he
remained dedicated to
the organization.

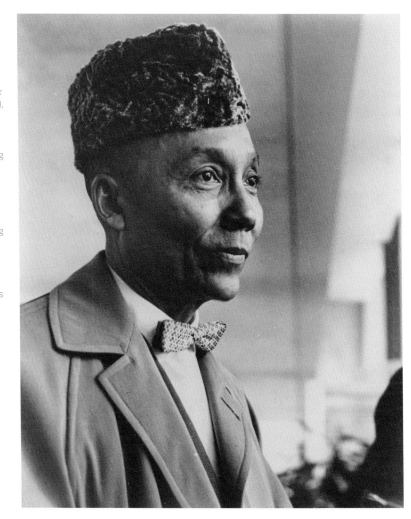

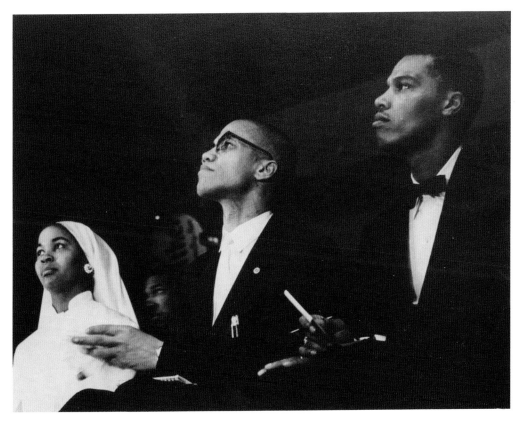

Malcolm X and Louis Farrakhan, ca. 1959
Lloyd W. Yearwood
—

In 1952, Elijah Muhammad met Malcolm X, who soon became Muhammad's national spokesman. Malcolm's keen intellect and ability to connect fruitfully with his audiences augmented the NOI's membership and heightened its media profile. After establishing a temple in Boston, Massachusetts, Malcolm chose a twenty-three-year-old assistant minister, Louis Farrakhan, who often shared the stage with Malcolm and would lead the NOI after Muhammad's death in 1975. Here, Farrakhan and Malcolm X are pictured alongside a member of the Muslim Girls Training and General Civilization Class.

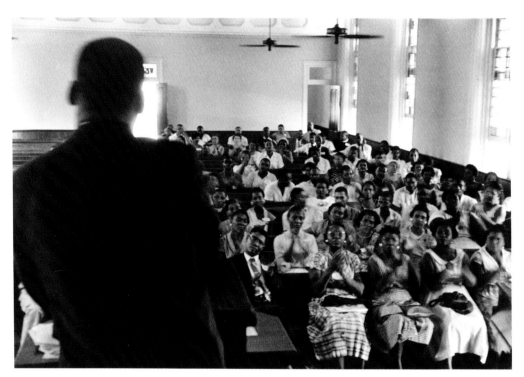

Martin Luther King Jr., Dexter Avenue Baptist Church, Montgomery, Alabama, 1955; printed 2008
Charles Moore
—

In these images, we see two distinct generations of civil rights activists engaging in the Black prophetic tradition of preaching and oration to galvanize concerned citizens against anti-Black racism. Rev. Dr. Martin Luther King Jr. is seen speaking—in a suit—to a crowd at Dexter Avenue Baptist Church in Montgomery, Alabama. Similarly, millennial Black Lives Matter activist Janaya "Future" Khan addresses a large crowd outside—with a bandana wrapped around their head and black T-shirt—at a Black Lives Matter protest in Hollywood, California. While they hail from different generations, both activists employ the Black tradition of sacred rhetoric as a means for fighting injustice.

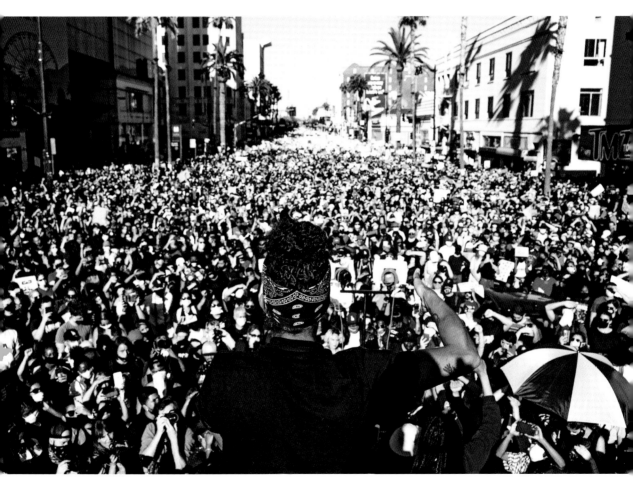

Janaya Khan at a Black Lives Matter protest in Hollywood, June 7, 2020
Tommy Oliver

MOTIONS

Melanee C. Harvey
Howard University

Historically, the motion of Black religious life has shaped the spiritual and sociopolitical contours of American culture. This group of photographs shows more than the physical gesturing exhibited in religious gatherings and ceremonies. These images highlight performative encounters, which scholar Yolanda Covington-Ward defines as movement "used strategically in everyday life to transform interpersonal social relationships in meaningful ways."[1] Photographs in black and white and color document the motion of Black religious communities that transforms the participants and the spaces they inhabit.

Elevated arms communicate call-and-response rituals in Black religious communities as seen in Jason Miccolo Johnson's photograph of Bishop T. D. Jakes (see page 51). This picture captures the physicality of guiding congregations through religious service, from the concentration in the furrow of his brow to the sweat cascading from his temples. The mid-twentieth-century photograph of the founder of the International Peace Movement Mission, the Reverend Major Jealous Divine (see page 50), popularly known as Father Divine, standing before a radio set, raising the Bible, demonstrates the use of technology to create community and proselytize.

In Black Christian traditions, music has consistently been an important catalyst for motion. The studio portrait of the C. & M. A. Gospel Quintette (see page 54) illuminates the role photography played in advertising new genres of gospel performance. Milton Williams's photograph of musicians from the United House of Prayer for All People (see page 52) documents the sacred rhythmic swing created by percussionists and trombone choirs of this denomination. These photographs illustrate the dynamic relationship between sound and motion across Black religious traditions.

Collective movement, in religious exercises or navigating social spaces, reveals the power of mobilizing religious masses. From the processions of the Church of Halie Selassie I in Brooklyn documented by Chester Higgins (see page 59), to the discipline visible in Roderick Terry's *Fruit of Islam* (see page 58), these images exemplify different types of performance that Black religious communities employ to inscribe meaning across their environment. Similarly, communing with nature for spiritual advancement is

foundational for the Brooklyn–based Black, indigenous, and women of color health collective Harriet's Apothecary (see page 57).

Photographs that capture quiet moments of motion emphasize the power of human connection. In John H. White's photograph of a nun comforting an incarcerated man in a Chicago jail (see page 48), the contrast between dark and white tones conveys the empathy in human touch. During the isolation of the COVID-19 pandemic, conceptual artist Lola Flash reflected on this circumstance through self-portraiture. Occupying a site usually packed with New York commuters,

Flash documented this space with a posture of prayer, protected by gloves, a mask, and an Afrofuturistic astronaut helmet. *I Pray* conveys the ease and accessibility of prayer, even in secular contexts, to purify, sustain, reflect, reorient, and express gratitude. Together, these photographs redefine religious iconography, by projecting a visual spectrum of individual and communal motion that transforms sacred and secular spaces.

1. Yolanda Covington-Ward, "Introduction: Gesture and Power," *Gesture and Power: Religion, Nationalism, and Everyday Performance in Congo* (Durham, NC: Duke University Press, 2016), 9.

I Pray, 2020
From the series
syzygy, the vision
Lola Flash

—

Photographer Lola Flash's series *syzygy, the vision* explores mass incarceration and Afrofuturism, a movement fusing futuristic themes with Black culture. In this self-portrait, Flash's outfit and the setting demonstrate that anywhere can become a sacred space.

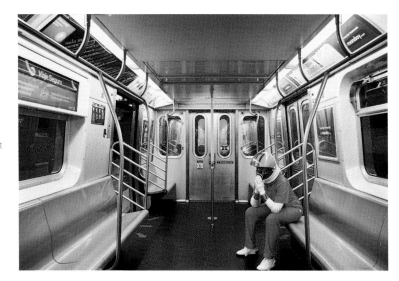

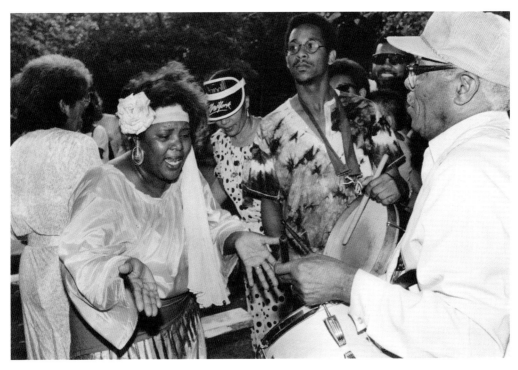

***Festa de João Batista,
Brockton***, 1986–90
From the series
**Cape Verdeans in
the Boston Area of
Massachusetts and
in the Cape Verde
Islands**
Beverly Conley
—

This lively festival
celebrating John the
Baptist's birthday
captures the multilayered
culture of immigrants
from Cape Verde Islands,
off the coast of West
Africa, who settled in
Massachusetts, the
leading destination of
Cape Verdeans who
migrate to the United
States. Cape Verdeans

have formed strong
communities in the
United States where
they can celebrate their
unique identity; the
Massachusetts census
even offers "Cape-
Verdean" as an option
for ethnic identification.
Most of the immigrants
speak Cape Verdean
Creole, a mix of African
and Portuguese, and the

local Roman Catholic
church of St. Edith Stein
offers services in this
language. Cape Verdean
and other American
Catholics celebrate
the same holidays, but
Cape Verdean religious
festivals are distinguished
by drumming and
African-influenced dance.

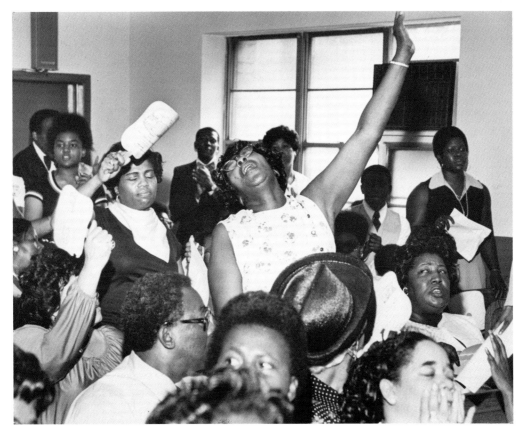

Carolina Baptist Church, late 20th century
Milton Williams

Community in Prayer,
1940
From the series
**The Commandment
Keepers: African
American Jewish
Congregation in
Harlem**
Alexander Alland

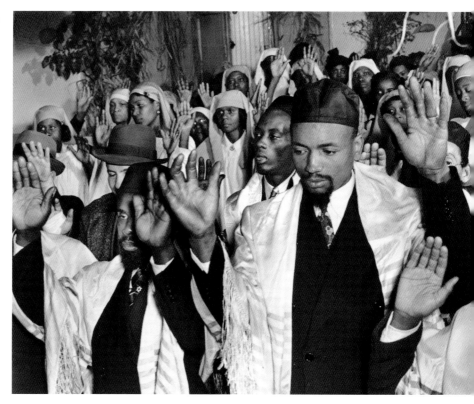

Praises, 1996
From the series
Praise
Kenneth Royster

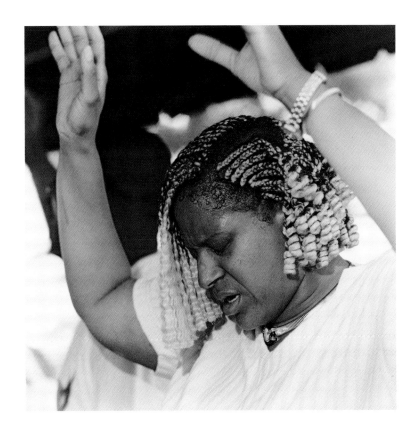

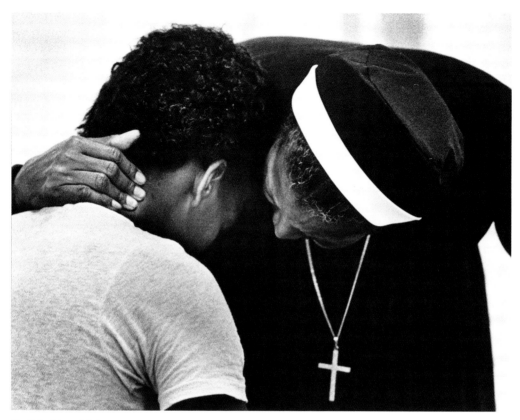

Untitled, late 20th century
John H. White
—

This photograph brings into focus the experiences of dedicated religious practitioners who provide pastoral care beyond the bounds of traditional religious institutions.

Outside the public eye, they engage with and provide support to the marginalized, including those who have been incarcerated. In the 1970s, the Cook County Jail in Chicago, Illinois, became a central spot for faith practitioners such as Mother Consuella York (likely pictured here), who became known as the "Jail Preacher" for her prison ministry. In this photo, we see an emotional exchange as the older clergywoman comforts a younger man who is imprisoned.

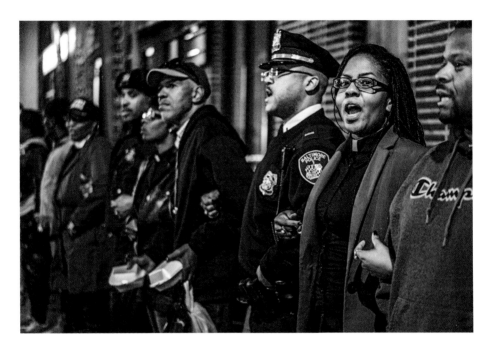

Untitled, December 15, 2015
Devin Allen

—

Members of different faith communities join hands with protesters and law enforcement in this photograph of prayer circle participants during one of the many protests that occurred after the death of 25-year-old Freddie Gray while in the custody of Baltimore City Police in April 2015.

More than four hundred people were arrested and more than $20 million in costs, including police overtime and property damage to businesses, were incurred during three weeks of unrest that roiled the city. The day of the prayer circle, the city was on edge, waiting for the verdict in a trial of one of the six officers involved in Gray's arrest. Ultimately, none of them were convicted.

As an acolyte of the great Gordon Parks, photojournalist Devin Allen finds his core inspiration in his environment, the streets of Baltimore's inner-city African American neighborhoods. Working primarily in the stark depictions of black-and-white photographs, his images seek to capture the immediacy of his subjects' lives while freezing a moment in time—conveying the immutable reality of their everyday experiences.

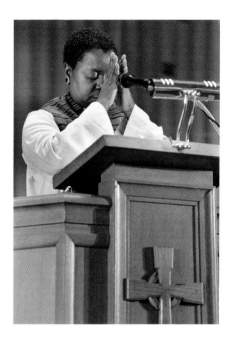

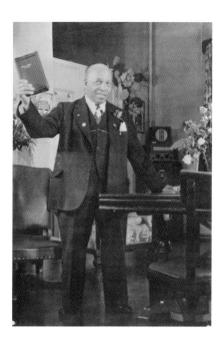

Dr. Jacquelyn Grant Prays that Her Words Might Be Blessed before Delivering the Morning Sermon on Annual Women's Day at Allen Temple Baptist Church, Oakland, California, 1998; printed 2012
Jason Miccolo Johnson
—

Illustrious African American religious practitioners often initiate methods of preparation prior to embarking on transformational sermons. Traditional methods of preparation include meditation, singing, and prayer. Here, Rev. Dr. Jacquelyn Grant, a principal architect of Womanist theology, readies herself to deliver a preamble prayer. Her perfectly positioned hands denote a relationship with her Creator, and her closed eyes appear to uplift and focus her, while her bowed posture projects a humble reverence.

Father Divine, ca. 1940
Unidentified photographer
—

Rev. Major Jealous Divine, also known as Father Divine, was a charismatic leader whose followers regarded him as God on Earth. Divine, who believed in racial equality and economic self-sufficiency, founded and led the International Peace Mission movement. Peace Missions around the country provided employment and affordable food, clothing, and shelter to followers, helping the movement grow during the Great Depression. Here, Father Divine's raising of the Bible references the practice of Biblical memorization and recitation that unites members during religious events.

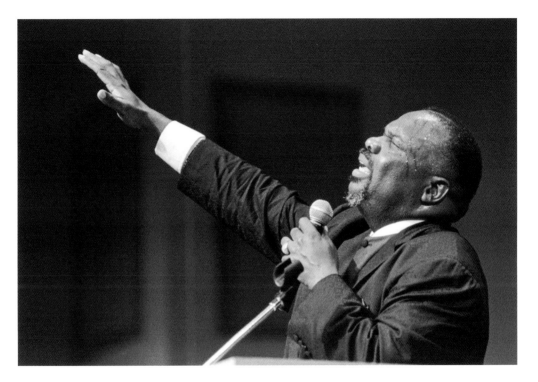

Bishop T. D. Jakes, Pastor of The Potter's House in Dallas, Texas, Is Guest Preacher at Metropolitan Baptist Church, Washington, D.C., 1999; printed 2012
Jason Miccolo Johnson
—

With humble beginnings in the hills of West Virginia, Bishop Thomas Dexter Jakes emerged on the global scene as a leading American clergyman, orator, media mogul, and entrepreneur.

The senior pastor of The Potter's House, a Dallas megachurch, Jakes's rhetorical gifts and inspirational musings have earned him the reputation of being one of the most effective

preachers in the English-speaking world. Informed by the percussive and ecstatic worship traditions of his formative Black Pentecostal roots, Bishop Jakes is photographed here in

a "preaching moment," leading the congregants of Washington's Metropolitan Baptist Church in worship.

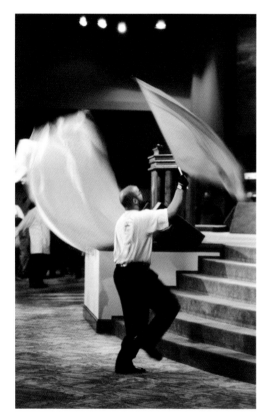

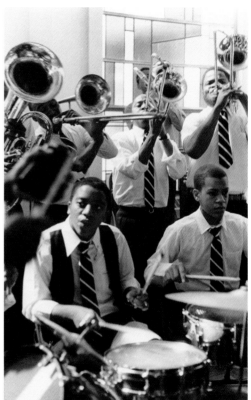

**A Member of the Praise Team Uses Flags
to Usher in the Spirit of the Lord at Evangel
Fellowship COGIC, Greensboro, North Carolina,
2005**; printed 2012
Jason Miccolo Johnson

Untitled, late 20th century
**A shout band from The United House
of Prayer for All People**
Milton Williams

Revelations—Opening Section of "Pilgrim of Sorrow" Danced to "I Been 'Buked," 1978
Jack Mitchell
—

Revelations, a 36-minute dance set to spirituals, gospel, and blues music, is Alvin Ailey's best-known choreography and the signature work of the Alvin Ailey American Dance Theater. The three-part piece, which was inspired by Ailey's childhood memories of his rural church, tells the story of African American religion and spirituality from the suffering of enslavement to baptism and religious celebrations. *Revelations* premiered in 1960 and has been seen by more than 23 million people around the world. Seen here performing the opening section of "Pilgrim of Sorrow" are (front to back, left to right) Estelle Spurlock, Sarita Allen, Mari Kajiwara, Donna Wood (hidden), Judith Jamison, Jodi Moccia, Peter Woodin (hidden), Alistair Butler (hidden), and Melvin Jones.

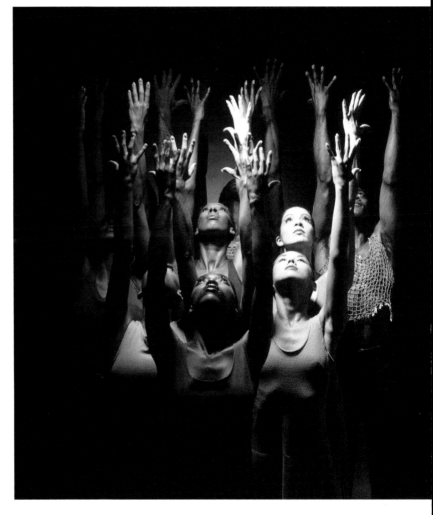

C. & M. A. Gospel Quintette, 1920–40
Unidentified photographer
—

John H. Parker formed the C. & M. A. Gospel Quintette in Cleveland, Ohio, in 1913. Part of the Christian and Missionary Alliance, an evangelical protestant denomination, the group performed around the United States and Europe from its founding through the 1930s. Pictured here are the five members of the group: (left to right) lead tenor Floyd H. Lacy, tenors John H. Parker and Spurgeon R. Jones, bass Alexander E. Talbert, and baritone Henry D. Hodges.

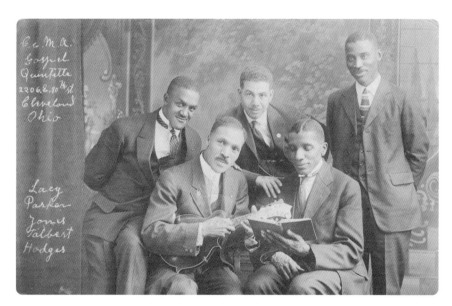

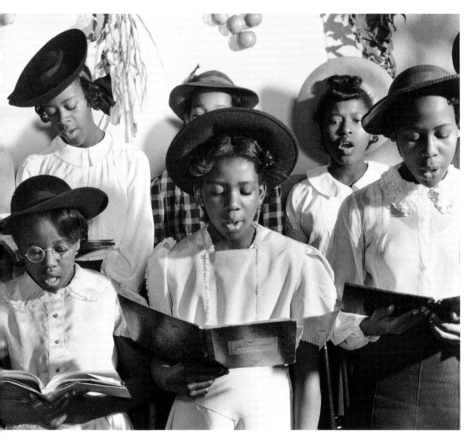

Young Female Choir,
1940
From the series
**The Commandment
Keepers: African
American Jewish
Congregation in
Harlem**
Alexander Alland

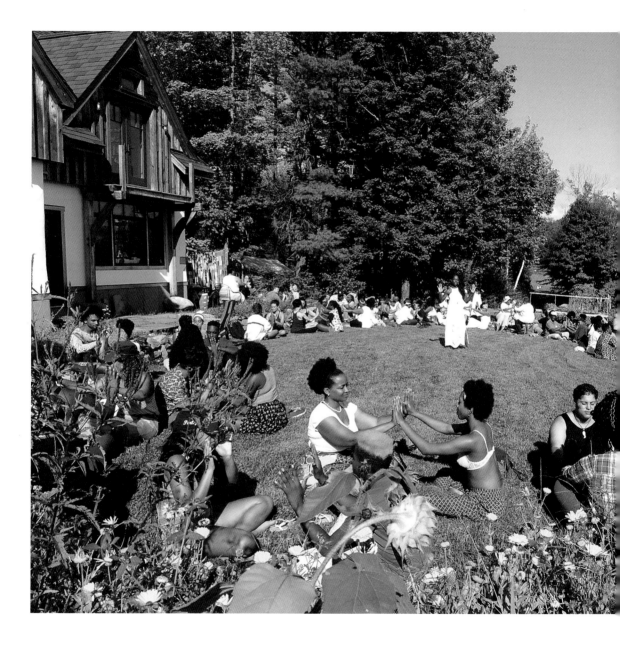

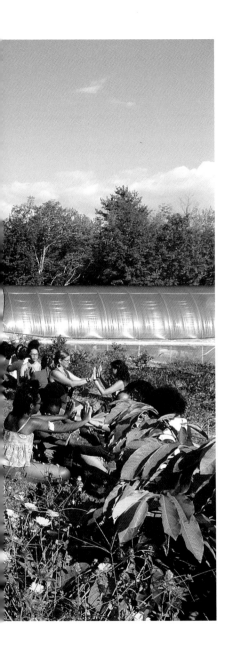

A Harriet's Apothecary healing village session at Soul Fire Farm, 2017
Neshima Vitale-Penniman
—

Founded by queer lgbo teacher and healer Adaku Utah, Harriet's Apothecary represents the very essence of Black bodies in motion, while shedding light on the various ways spaces can be curated for all identities and bodily abilities. Since its inauguration in 2014, Harriet's Apothecary has provided communal care through health and social initiatives that integrate healing and spiritual practices for the betterment of self and community, while communing with nature. By providing holistic services such as Reiki and spiritual divinations, the organization hopes that members will leave the space feeling renewed. With an emphasis on access and affordability, Harriet's Apothecary's radical approach to care provides an affirming space for all.

Pictured are participants in one of the organization's healing villages at the Soul Fire Farm in Petersburg, New York. An annual event, healing villages foster a discourse that centers both the individual and larger group, allowing them to pull back layers of injustices.

Fruit of Islam,
October 16, 1995
From the series **One
Million Strong**
Roderick Terry

Procession of Black Catholic leaders, 1987
Unidentified photographer
—

Pictured in procession during the Sixth National Black Catholic Congress at the Basilica of the National Shrine of the Immaculate Conception in Washington, D.C., are (left to right) Cardinal Wilton Daniel Gregory, Bishop Carl Fisher, Bishop Harold Perry, Bishop Joseph Francis, Archbishop Eugene Marino, Bishop Moses Anderson, Archbishop James Lyke, Bishop Emerson Moore, Bishop J. Terry Steib, and Bishop John Ricard.

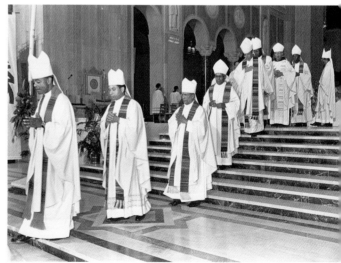

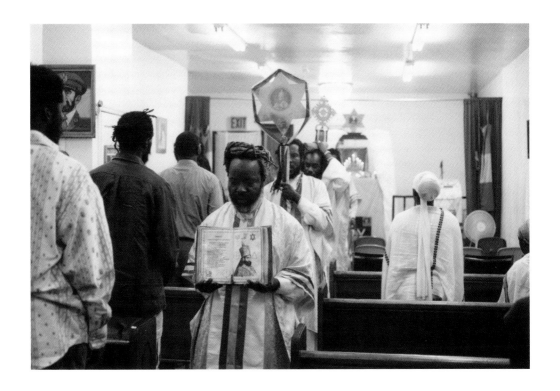

Rasta Church in Bedstuy, Procession, 2007;
printed 2021
Chester Higgins
—

Rastafari, a religious-
political movement that
began in Jamaica in the
1930s, blends Christianity,
Pan-Africanism, and
mysticism. During
a procession at the
Church of Haile Selassie I
in Brooklyn, New York,
Rastas carry images
of Haile Selassie I, the
emperor of Ethiopia from
1930 to 1974, whom many
practitioners regard as
the King of Kings and Lord
of Lords.

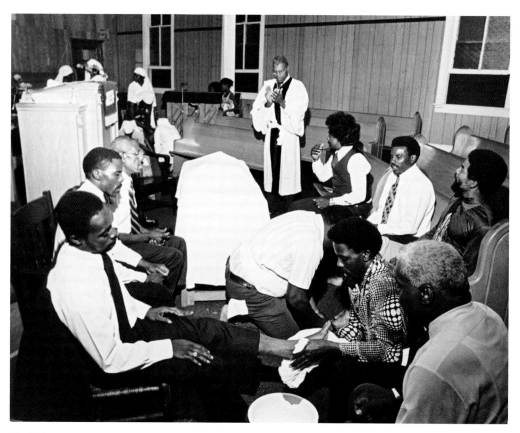

Christian "Foot Washing" at Hyattsville Md.
Washington Baptist Church by Men's Club
Members, October 1979
Milton Williams

***The Energetic and Powerful Bishop Abraham Mitchum, Sr. Renders
Deliverance through the Gift of "Laying on the Hands" at New Jerusalem
Temple Bible Way Church, Washington, D.C., 2003***; printed 2012
Jason Miccolo Johnson
—

The washing of feet is a religious observance practiced in Islamic, Sikh, and Christian traditions. Within Christianity, this religious moment is observed in accordance with the New Testament. Traditionally, foot-washing services are held on Maundy Thursday during Easter to commemorate Jesus washing his disciples' feet before the Last Supper. Opposite, Milton Williams captures a night foot-washing service in a Black Protestant church. Similarly, photographer Jason Miccolo Johnson captures Bishop Abraham Mitchum Sr. laying hands on a congregant at New Jerusalem Temple Bible Way Church in Washington, D.C. First practiced in Judaism, the "laying of hands" in Black religious traditions invokes the power of the Holy Spirt to heal, cleanse, bless, and deliver.

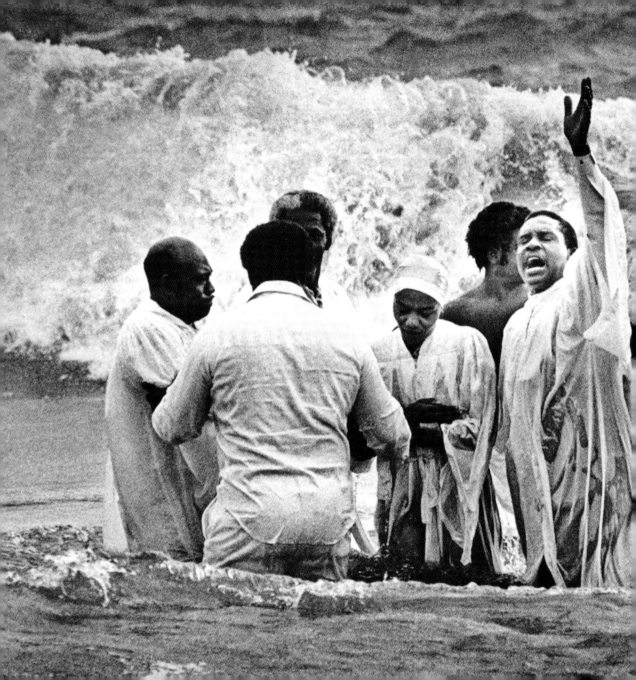

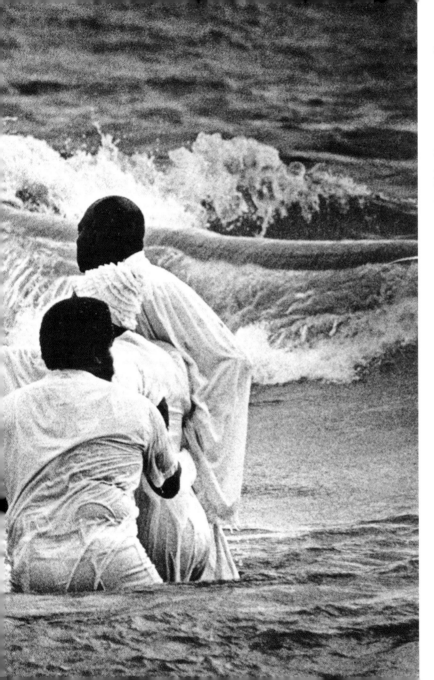

Untitled,
September 1981
**A baptism in Lake
Michigan**
John H. White

MOMENTS

Teddy Reeves
National Museum of African American History and Culture

Since the arrival of Africans on the shores of the Americas in the 1500s, generations of people of African descent have sought to reconstitute their faith and spiritual practices in the context of anti-Blackness. Beginning in the mid- to late nineteenth century, African Americans used images of religious moments to fight against and make meaning of the oppressive systems threatening their way of life and very existence. Photographs in this section capture this reframing—both within and beyond traditional religious spaces—through religious and spiritual moments: mourning and hope, protest and praise, organization and institutionalization, and tradition and futures.

As Erika D. Gault notes, anti-Black technologies policed early generations of Africans, circumscribing their religious rituals and traditions. For instance, colonial legislators labeled gatherings of Africans for burials "dangerous" and enacted laws against night funerals, preaching, and other traditional African ritualistic practices (singing, chanting, and drumming). Unable to embalm the deceased, the enslaved assigned guards, who were customarily women, to watch over bodies and to wash and wrap the deceased in white linen. At Harriet Tubman's funeral in 1913 (see page 82), the board of directors of the Harriet Tubman Home sat as a "guard of honor" over Tubman's casket at the Thompson Memorial AME Zion Church in Auburn, New York. Similarly, a photograph taken during Malcolm X's funeral shows his body shrouded in white linen, an Islamic burial practice (see page 83). These mourning traditions were occasions to refashion Black bodies, restore dignity, and affirm the humanity and personhood of the life that had passed. Through this process, they ensured that the deceased died well and could properly transition to the ancestral realm.

In the late nineteenth and early twentieth centuries, anti-Blackness was immortalized through the widespread accessibility of the camera. Mutilated Black bodies and elated white spectators were captured and printed on postcards, mailed, and used as memorabilia at public lynchings. With the rise of wired news services and Black photographers, African Americans countered those narratives to reclaim Black bodies and to positively portray, among other things, the religious moments that were the source of their spiritual power.

With the COVID-19 pandemic came new challenges. As mandates and safety concerns limited in-person contact, Black religious moments, including funerals, worship services, and celebrations, had no choice but to go virtual. At Cleveland's South Euclid United Church of Christ, Senior Pastor Rev. Courtney Clayton Jenkins preached to her congregation over Facebook with images of her congregants taped on chairs. Using video conferencing, cell phones, and social media platforms, Black religious leaders and institutions reconstituted themselves to meet the new constraints. Faith became increasingly *on demand*.

African Americans stand ready to use these visual technologies to assist in restoring their dignity and reinforcing their identity and pride in their lives—even as they remain under assault. The conditions that precipitate reconstitutions for each generation continue to change, yet no matter the time, place, or circumstance, rich religious moments practiced and reimagined by African Americans prevail.

Rev. Courtney Clayton Jenkins preaching to vacant pews at South Euclid United Church of Christ in Cleveland, Ohio, 2020
Nakeshia Nickerson

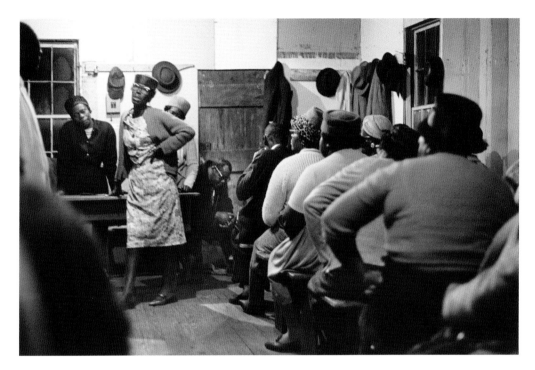

Christmas Eve Watch·Johns Island, SC, 1964;
printed 1998
Leonard Freed
—

As key markers of time, religious holidays are composed and intended to replicate the journeys of major religious figures. Each religious observance has its own customs and traditions that allow followers to both reflect and celebrate with loved ones. This photograph by Leonard Freed captures what he understood

as a Christmas Watch Night service at Moving Star Hall, one of the only one-room praise houses for African Americans on Johns Island, South Carolina. The hall was built by members of the Gullah-Geechee community and has played an integral role in the history and heritage of South Carolina's

coastal region, providing a place for worship and community gatherings.

Filled with spirituals, hymns, testimonies, and prayers, Watch Night, also referred to as Freedom's Eve, has remained a fixed tradition in Black communities to commemorate those who were enslaved.

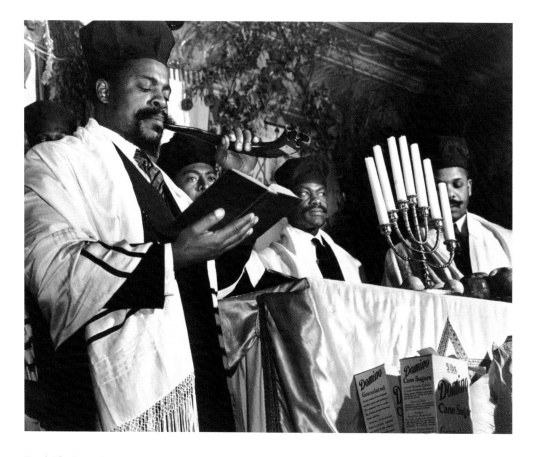

Rosh Hashanah, 1940
From the series **The Commandment Keepers: African American Jewish Congregation in Harlem**
Alexander Alland
—

Here Alexander Alland captured Rabbi Wentworth A. Matthew, founder of the Commandment Keepers Ethiopian Hebrew Congregation, during a Rosh Hashanah celebration. Rosh Hashanah is a two-day event that marks the Jewish New Year, celebrated during the seventh month of the Hebrew calendar.

Founded in 1919, the Commandment Keepers is considered one the oldest congregations of Black Hebrews in America. Rabbi Matthew founded the Commandment Keepers as part of an initiative to build an all-Black Jewish congregation in Harlem, New York.

***The Attendant in
Church Preparing
Wine for Communion***,
1979; printed 2007
From the series
Daufuskie Island
Jeanne
Moutoussamy–Ashe

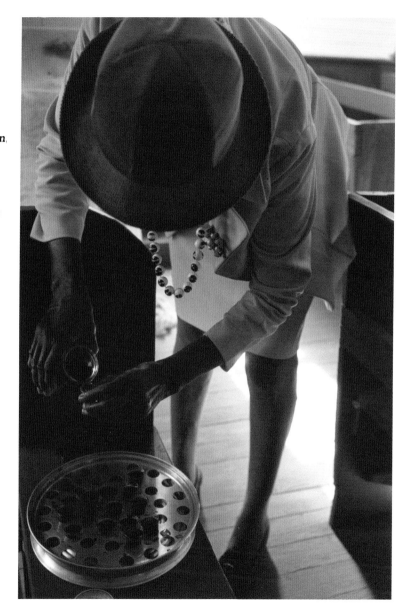

Chief Rabbi Levi Ben Levy with his son and godson at a Passover Seder at Beth Shalom Ethiopian Hebrew Congregation in Brooklyn, New York, ca. 1968
Lloyd W. Yearwood
—

Left to right: Sholomo Ben Levy, Chief Rabbi Levi Ben Levy, and Asa Manot.

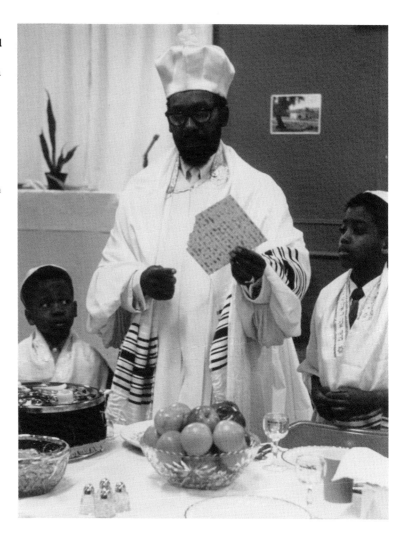

*The Mother's Counsel of True Light
Church Baptist Enjoys the Repast after
the Annual Woman's Day Program,
Chicago, Illinois, 2005*; printed 2012
Jason Miccolo Johnson

**Youth Usher Vivica Brooks Passes Out Fans to Congregants During Deacons',
Deaconesses', and Evangelists' Ordination Service at Righteous Church of God,
Washington, D.C., 2003**; printed 2012
Jason Miccolo Johnson

Women, both young and old, have immersed themselves into vital roles within the Black church to help sustain it as an important part of the Black community. The essence of Black womanhood has been the driving force in the church, keeping it afloat by ensuring process and order. Originally proposed by Nannie Helen Burroughs as part of the National Baptist Convention, many Black religious spaces have commemorated the domesticity of women during their annual Women's Day celebration. Burroughs, an activist, educator, and religious leader, believed that the agency and voice of women was worth celebrating and was a resource to bring forth additional opportunities to carry out missions across the world. These photos portray an intergenerational understanding of women in the church and the legacy it leaves for future generations.

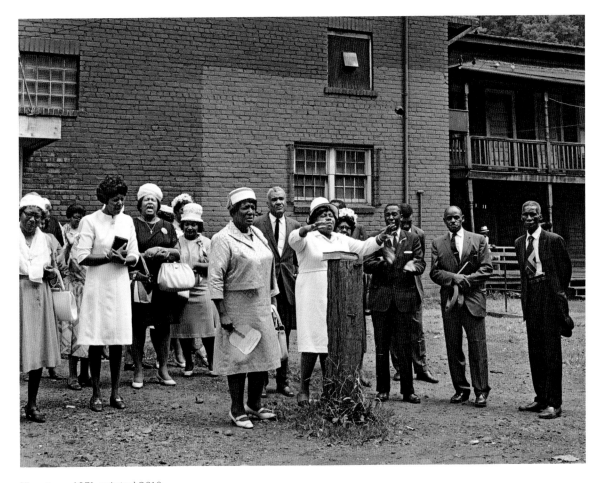

Keystone, 1971; printed 2010
Builder Levy

Sister Teresa at Pentecostal Street Service, 1964
From the series **The Puerto Rican Diaspora Documentary Project**
Frank Espada
—

The moments captured here showcase two different women leading services outside the bounds of brick-and-mortar institutions—one in the small but vibrant African American community in Keystone, West Virginia, and the other on a crowded New York City street. The two women are engaging from behind a podium, delivering messages both directly and indirectly to bystanders. Often, women would occupy outside spaces in efforts to extend participation, while also serving as a conduit between the church and the community.

Salat, 1990; printed ca. 2000
Chester Higgins
—

Chester Higgins is widely recognized for his striking images that explore the fullness and beauty of African American life, particularly religious life. While attending Tuskegee University, Higgins met P. H. Polk, the school's legendary official photographer. Polk inspired Higgins to use photography as an art form to highlight Black dignity and strength. Higgins went on to introduce beautiful, dignified everyday images of Black Americans in the popular media for four decades as a staff photographer at the *New York Times*.

Faith has been an important part of Higgins's personal life since his childhood and is a quality that translates into his images. Higgins tries to capture "the spirit" in all his work. In this photograph, he depicts a man performing salat, a ritual Muslim prayer that is completed five times a day. As with many of his images, this photograph shows the beauty and significance of ritual in everyday Black religious life.

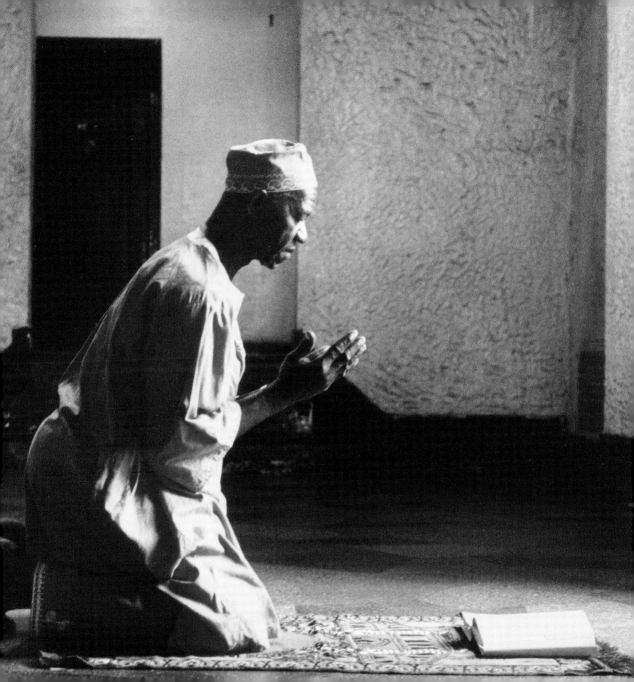

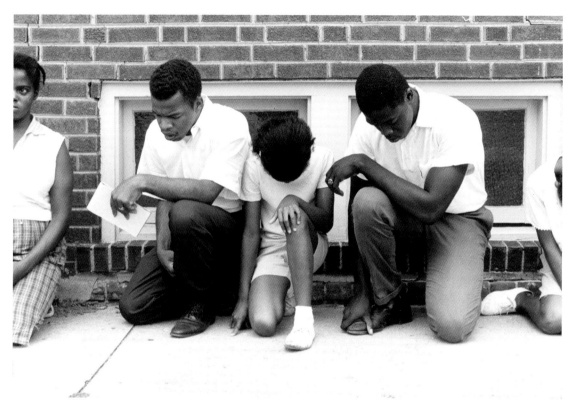

Cairo, Illinois. SNCC Field Secretary, Later SNCC Chairman, Now Congressman John Lewis, and Others Pray During a Demonstration, 1962; printed 1994
Danny Lyon
—

As a young activist, Rev. John Lewis (pictured kneeling, far left) practiced peaceful protest and suffered beatings during the Freedom Rides in 1961—the same year he was ordained a

Baptist minister—and the Selma voting rights marches in 1963. At the age of twenty-three, Lewis became chairman of the Student Nonviolent Coordinating Committee (SNCC), which organized

student-led protests such as "kneel-ins" (kneeling in prayer in protest to segregation). Lewis sought "good trouble" throughout his career in the name of social justice.

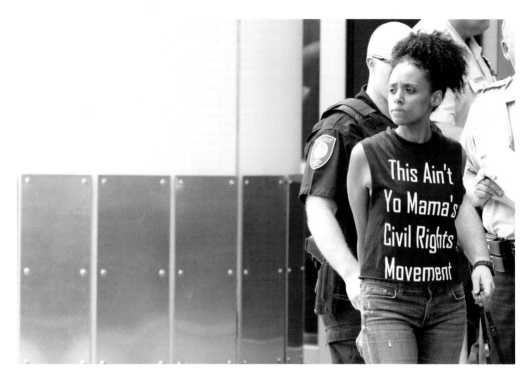

This Ain't Yo Mama's Civil Rights Movement,
August 10, 2015
Heather Wilson
—

Today's activists build upon the knowledge and traditions of those who came before, but they also bring new perspectives and approaches. Rahiel Tesfamariam, pictured here in St. Louis, Missouri, when she was arrested during a peaceful protest recognizing the one-year anniversary of the killing of Michael Brown, purposefully and simultaneously signals her solidarity with and divergence from the church-led freedom movement of the 1960s by wearing a T-shirt emblazoned with the motto "This Ain't Yo Mama's Civil Rights Movement." Tesfamariam, a writer, activist, and public theologian, is forging a path for young activists, providing a model for combining faith with a commitment to social justice, addressing persistent injustice while exploring hip-hop spirituality, and harnessing social media for social change. Her portrait is emblematic of the shifting intersections of history, activism, and faith.

David Doré's bar mitzvah ceremony overseen by his grandfather, Rabbi Wentworth A. Matthew, at the Commandment Keepers Ethiopian Hebrew Congregation in Harlem, New York, ca. 1968
Lloyd W. Yearwood
—

At the age of sixteen, David Doré became one of the youngest rabbis in America when his grandfather, Rabbi Wentworth Arthur Matthew, founder of the Commandment Keepers Ethiopian Hebrew Congregation, ordained him in 1971.

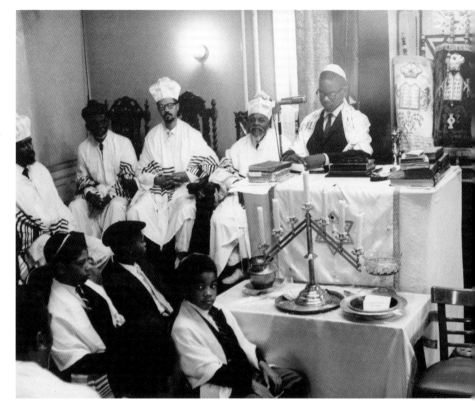

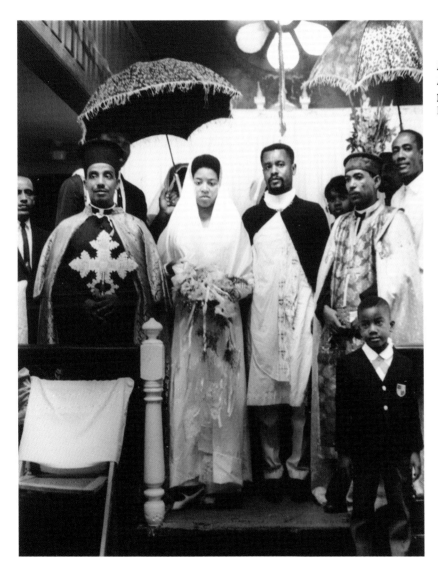

**An Ethiopian
American wedding
party**, ca. 1960
Lloyd W. Yearwood

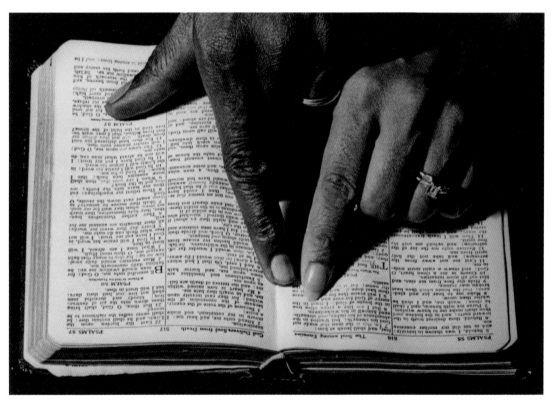

**Two hands pointing
at a Bible passage**,
ca. 1968
Robert Houston
—

Following the
assassination of Rev.
Dr. Martin Luther King
Jr., photographer Robert
Houston embarked on
a journey to capture
intimate moments of the
Civil Rights Movement. In
this photo, an unidentified
couple engages in reading
what appears to be a
verse from Psalm 52,
which reads, "But I am like
a green olive tree in the
house of God: I trust in the
mercy of God's unfailing
love for ever and ever."
The collections of Psalms
have been a source of
refuge and solace for
many in times of despair.

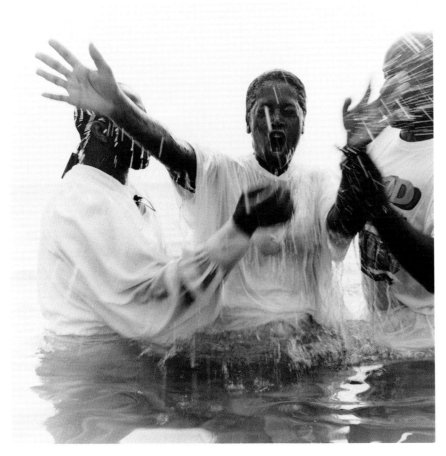

***The Baptism of
Ms. Robinson***, 1995
From the series
Praise
Kenneth Royster

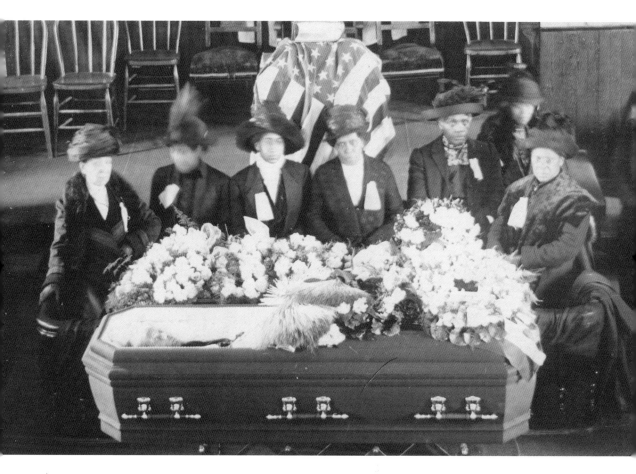

**Harriet Tubman lying in repose in Auburn,
New York**, March 11, 1913
Unidentified photographer

Malcolm X Funeral,
1965; printed later
Bob Adelman

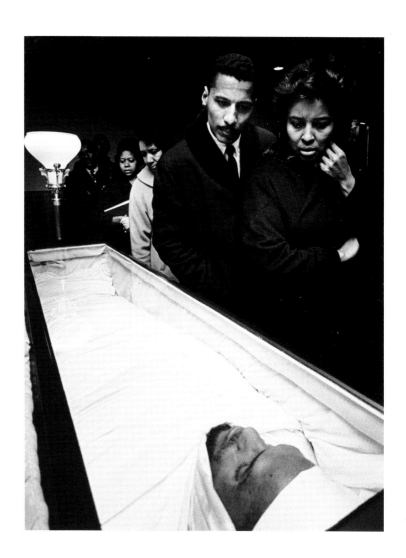

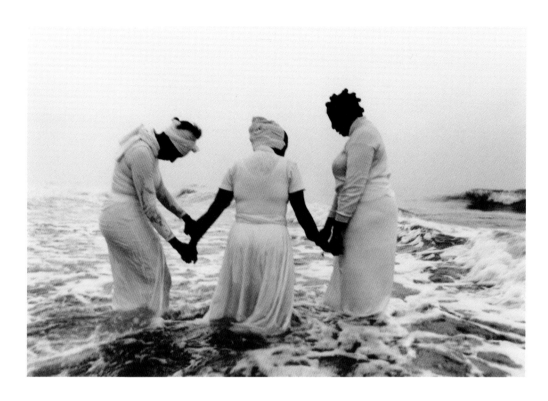

Ancestral Memorial, Coney Island, 1995
Chester Higgins

—

Since the earliest days of the involuntary presence of Africans on the continent of North America, enslaved Africans and their descendants have created ritual practices to mark the remembrance of their ancestors' voyages from Africa to the shores of the Americas. Such is the mission of the People of the Sun Middle Passage Collective of New York City. In establishing the annual African Ancestral Memorial, the collective commemorates the lives of enslaved Africans who perished during the Middle Passage. Combining elements of both Christianity and African traditional religions, and incorporating singing, drumming, prayers, and libations, the practitioners pictured here, dressed in white, perform healing rituals while wading in the waters of Brooklyn's Coney Island Bay.

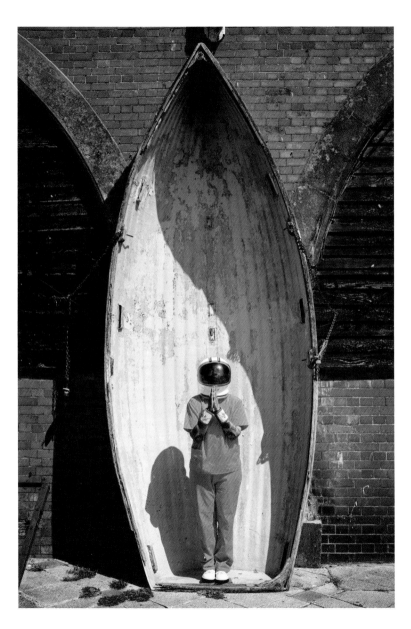

Divinity, 2020
From the series
syzygy, the vision
Lola Flash
—

Photographer Lola Flash writes of their series *syzygy, the vision:* "My soul is hopeful for a divine future where we are finally able to run anew, jumping in space from planet to planet . . . into a narrative of pure joy." The self-portrait *Divinity* shows Flash wearing an orange prison uniform and a space helmet while standing inside a boat in a position of prayer—an image reminiscent of a religious statue framed inside a protective grotto.

Index

All of the photographic materials are in the collection of the National Museum of African American History and Culture

Roderick Terry
Fruit of Islam, October 16, 1995
From the series **One Million Strong**
gelatin silver print
H × W (Image and Sheet):
11 × 14 in. (27.9 × 35.6 cm)
Gift of Roderick Terry
2013.99.19
© Roderick Terry
Page 58

Unidentified photographer
C. & M. A. Gospel Quintette,
1920–40
gelatin silver postcard
H × W (Image and Sheet):
3⁷⁄₁₆ × 5⁷⁄₁₆ in. (8.7 × 13.8 cm)
2013.46.23
Page 54

Unidentified photographer
Father Divine, ca. 1940
gelatin silver print
H × W (Image and Sheet):
30 × 20 in. (76.2 × 50.8 cm)
2012.46.72
Page 50

Unidentified photographer
Harriet Tubman lying in repose in Auburn, New York, March 11, 1913
gelatin silver postcard
H × W (Image and Sheet):
3⅜ × 5⅜ in. (8.6 × 13.7 cm)
Gift of Charles L. Blockson
2009.50.33.1
Page 82

Unidentified photographer
Men and women in front of Vernon AME Church, Tulsa, ca. 1919
gelatin silver print
H × W (Image and Sheet):
7 × 10 in. (17.8 × 25.4 cm)
Gift of Princetta R. Newman
2014.75.40
Page 37

Unidentified photographer
Procession of Black Catholic leaders, 1987
gelatin silver print
H × W (Image and Sheet):
8 × 10 in. (20.3 × 25.4 cm)
Gift of Tower Hill Atlantic
2022.20.1
Page 58

Unidentified photographer
Sisters of the Holy Family disembarking on a mission to Belize, 1898
gelatin silver print
H × W (Image and Sheet):
4½ × 6¼ in. (11.4 × 15.9 cm)
Gift of the Sisters of the Holy Family, New Orleans
TA2018.74.1.1
Pages 11 and 31

Unidentified photographer
U.S. Senator Hiram Revels, early 1870s
albumen carte-de-visite
H × W (Image and Mount):
3⅞ × 2¹⁄₁₆ in. (9.9 × 6.2 cm)
2019.28.37
Page 36

James Van Der Zee
Moorish Zionist Temple, New York City, 1929; printed 1985
half-tone print postcard
H × W (Image and Sheet):
4¼ × 6 in. (10.8 × 15.2 cm)
Gift of Raheem and Aisha Adolemaiu-Bey
2012.101.8
© James Van Der Zee Archive, The Metropolitan Museum of Art
Page 26

Neshima Vitale-Penniman
A Harriet's Apothecary healing village session at Soul Fire Farm, 2017
digital image
Gift of Harriet's Apothecary and Soul Fire Farm
2021.112.2
© Adaku Utah
Page 57

John H. White
Untitled, late 20th century
gelatin silver print
H × W (Image and sheet):
11 × 14 in. (27.9 × 35.6 cm)
Gift of John H. White/Pulitzer Prize-Winning Photojournalist
2016.118.16
© John H. White
Page 48

John H. White
Untitled, late 20th century
gelatin silver print
H × W (Image and sheet):
11 × 17 in. (27.9 × 43.2 cm)
Gift of John H. White/Pulitzer Prize-Winning Photojournalist
2016.118.24
© John H. White
Page 17

John H. White
Untitled, September 1981
A baptism in Lake Michigan
gelatin silver print
H × W (Image and Sheet):
11¹¹⁄₁₆ × 16½ in. (29.7 × 41.9 cm)
Gift of John H. White/Pulitzer Prize-Winning Photojournalist
2016.118.22
© John H. White
Pages 10 and 63

Milton Williams
Carolina Baptist Church, late 20th century
gelatin silver print on mounting board
H × W (Image and Sheet):
7⅞ × 9⅞ in. (20 × 25.1 cm)
Gift of Milton Williams Archives
2011.15.41
© Milton Williams
Page 45

Milton Williams
Christian "Foot Washing" at Hyattsville Md. Washington Baptist Church by Men's Club Members, October 1979
gelatin silver print on mounting board
H × W (Image and Sheet):
7⅞ × 10 in. (20 × 25.4 cm)
Gift of Milton Williams Archives
2011.15.21
© Milton Williams
Page 60

Milton Williams
Untitled, January 8, 1977
Rev. Dr. Pauli Murray being ordained at the Washington National Cathedral
gelatin silver print
H × W (Image and Sheet):
8 × 10¼ in. (20.3 × 26 cm)
Gift of Milton Williams Archives
2011.15.230
© Milton Williams
Page 33

Heather Wilson
This Ain't Yo Mama's Civil Rights Movement, August 10, 2015
digital image
2021.81
© Heather Wilson
Page 77

Lloyd W. Yearwood
Chief Rabbi Levi Ben Levy with his son and godson at a Passover Seder at Beth Shalom Ethiopian Hebrew Congregation in Brooklyn, New York, ca. 1968
chromogenic print
H × W (Image and Sheet):
20 × 16 in. (50.8 × 40.6 cm)
2014.150.12.1
© Estate of Lloyd W. Yearwood
Page 69

Lloyd W. Yearwood
David Doré's bar mitzvah ceremony overseen by his grandfather, Rabbi Wentworth A. Matthew, at the Commandment Keepers Ethiopian Hebrew Congregation in Harlem, New York, ca. 1968
gelatin silver print
H × W (Image and Sheet)
11 × 14 in. (27.94 × 35.56 cm)
2014.150.9.8
© Estate of Lloyd W. Yearwood
Page 78

Lloyd W. Yearwood
Elijah Muhammad, ca. 1955
gelatin silver print
H × W (Image and Sheet):
10 × 8 in. (25.4 × 20.3 cm)
2014.150.5.7
© Estate of Lloyd W. Yearwood
Page 38

Lloyd W. Yearwood
An Ethiopian American wedding party, ca. 1960
gelatin silver print
H × W (Image and Sheet):
9¹³⁄₁₆ × 6⅞ in. (25.2 × 17.5 cm)
2014.150.3.17
© Estate of Lloyd W. Yearwood
Page 79

Lloyd W. Yearwood
Jesse Jackson at Abyssinian Baptist Church, ca. 1988
ink on paper
H × W (Image and Sheet):
8⅛ × 10 in. (20.6 × 25.4 cm)
2014.150.1.12
© Estate of Lloyd W. Yearwood
Page 21

Lloyd W. Yearwood
Malcolm X and Louis Farrakhan, ca. 1959
ink on paper
H × W (Image and Sheet):
8 × 10 in. (20.32 × 25.4 cm)
2014.150.7.45
© Estate of Lloyd W. Yearwood
Page 39